Collins

Learn to Paint
Abstracts

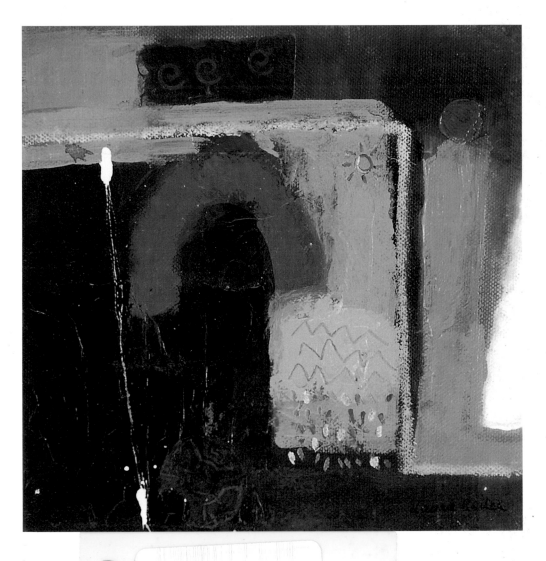

Laura Re

D0610084

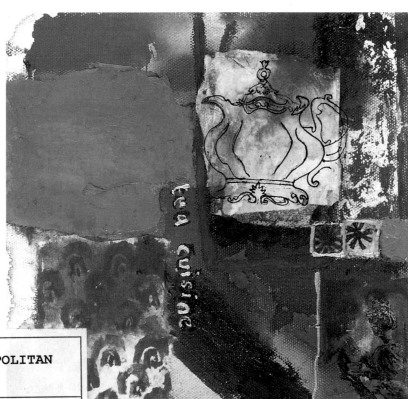

KIRKLEES METROPOLITAN
COUNCIL

250612499	
Bertrams	02.05.07
751.4	£9.99
HU	CUL43046

First published in 2006 by
Collins, an imprint of
HarperCollinsPublishers
77-85 Fulham Palace Road
Hammersmith, London W6 8JB

The Collins website address is:
www.collins.co.uk

Collins is a registered trademark of HarperCollins Publishers Limited.

07 09 11 10 08 06
2 4 6 8 7 5 3

© Laura Reiter 2006

Laura Reiter asserts the moral right to be identified as the author of this work.

All rights reserved. No part of this publication may be reproduced, stored in a retrieval system,
or transmitted, in any form or by any means, electronic, mechanical, photocopying, recording or
otherwise, without the prior written permission of the publishers.

A catalogue record for this book is available from the British Library.

Editor: Patsy North
Designer: Penny Dawes
Photographer: Patricia Rayner

ISBN-13 978 0 00 720272 0
ISBN-10 0 00 720272 5

Colour reproduction by Colourscan, Singapore
Printed and bound by Printing Express Ltd, Hong Kong

Previous page: **Sun Sign,** *mixed media on canvas, 20 x 20 cm (8 x 8 in)*
This page: **Tea Cuisine,** *mixed media on canvas, 20 x 20 cm (8 x 8 in)*
Opposite: **Running Horse Standing,** *mixed media on canvas, 45 x 60 cm (18 x 24 in)*

Contents

Portrait of an Artist 4

What is Abstract Painting? 6

Materials and Equipment 8

Using Colour 12

Mark-making Techniques 14

Working with Collage 20

Design and Composition 22

Making a Start 28

Developing a Natural Form 32

Altering Shapes 36

Using Photographs 38

Cutting up a Drawing 42

Extracting a Section 46

The Emotional Response 50

DEMONSTRATION ONE
Pink Watermelon 52

DEMONSTRATION TWO
Wood for the Fire 56

DEMONSTRATION THREE
Moonshine 60

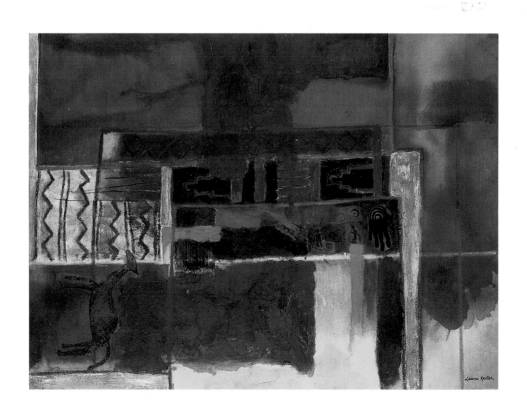

Portrait of an Artist

Laura Reiter was born and grew up in the suburbs of London, where she still lives. On leaving school, she began to work as a secretary but always knew that what she really wanted to do was pursue a career in art. However, it was not until later, while bringing up her children, that she studied art at Kingston and Wimbledon Schools of Art, where she attained first a BA degree in painting and then an MA in printmaking.

Laura's work has always tended towards abstraction, although in more recent years, while retaining the essence of an abstract painter, she has allowed some elements of figuration to creep in. She enjoys the activity of the actual making of her artwork which, for her, is very much part of the creative journey. Working in mixed media, she uses 'anything and everything that comes to hand', including watercolour, acrylics, collage and pastels. Her day-to-day life and her travels to parts of the world such as southeast Asia are a major source of inspiration for her paintings, which

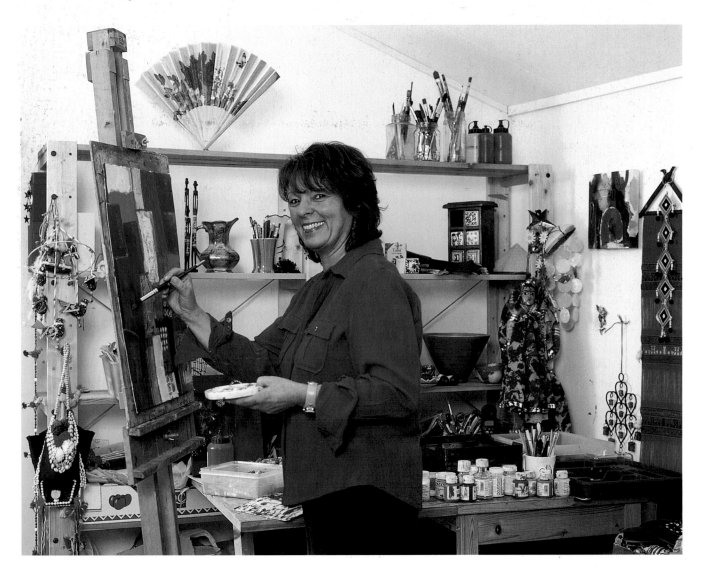

▼ Laura Reiter painting in her studio.

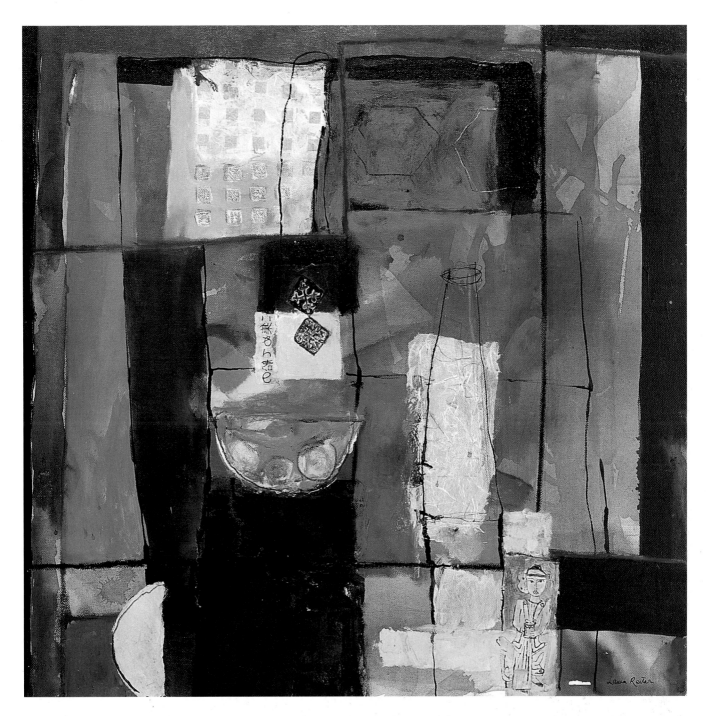

encompass and represent memories of and feelings about these events.

Laura has had success in selling her work, exhibiting in galleries such as the Bankside Gallery and the Mall Galleries in London. She regularly exhibits with the Linda Blackstone Gallery and the Battersea Affordable Art Show. She took part in a two-person show at the Manchester Royal Exchange Theatre Gallery and a one-person show at the Lyric Theatre, Hammersmith.

As well as this, Laura has won some prizes for her work, including three prizes at the C21 exhibition at the Bankside and three prizes at the Patchings Exhibition held by *The Artist* magazine. As well as pursuing her own work, she has taught extensively in academic settings such as colleges and schools. She has also taught art to adults in art centres and on painting holidays, in addition to running her own workshops and giving demonstrations to art societies.

▲ **Little Drummer**
mixed media on canvas
60 x 60 cm (24 x 24 in)
The 'little drummer' motif in the bottom right-hand corner is drawn from a small item I bought while in Thailand, as are the red-and-white purse and the bowl sitting below it.

What is Abstract Painting?

The term 'abstract' in painting is a general description of art that is not directly representational. An artist can move a small way towards the abstract by, for example, altering the shapes or colours of objects, or the whole way by allowing the painting to be entirely about the essence of the chosen subject without regard to its physical appearance.

How did it begin?

The invention of the camera in the nineteenth century freed artists from the responsibility for reproducing realistic representations of the world they lived in. The Impressionists were the first to experiment with different ways of painting that made use of new technology in paint

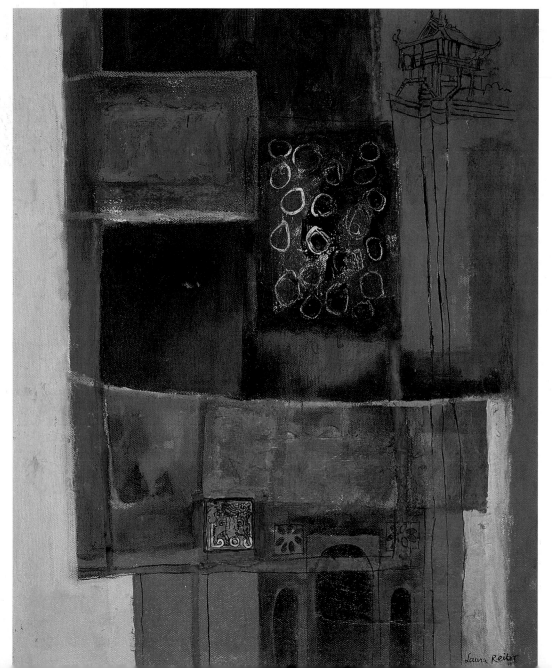

◄ **Old Hanoi**
mixed media on canvas
51 x 41 cm (20 x 16 in)
Hanoi is a unique city – colourful, exciting and busy. This painting represents a memory of the place. The patterns remind me of those on the buildings and myriad textiles and merchandise in the old market, together with archways leading to nooks and crannies that I found during my visit there.

manufacture and innovative theories of colour and light. The Impressionists paved the way for the Expressionist painters in the late nineteenth and early twentieth centuries and, subsequently, for the Cubists and Surrealists who, with the emergence of the new science of psychology, began to experiment with the expression of emotions, atmosphere and the spiritual. At the same time these artists were beginning to flatten out the picture space, thereby losing the illusion of three dimensions. You may like to look at artists such as Claude Monet (1840-1926), Wassily Kandinsky (1866-1944) and, of course, Pablo Picasso (1881-1973) to see how different styles of abstract painting began to develop.

Trying out new ideas

Many students of art and, indeed, artists themselves, are afraid of the word 'abstract' but express a desire for new subject matter, or have come to the point where they are bored with the work they are producing and are searching for a fresh approach. If you like experimenting with surfaces and materials and want to try out new ideas and techniques, but are unsure how to go about it, this book will guide you through the process step by step. Find out how to create abstract images from recognisable objects or scenes. Discover, too, how paintings can

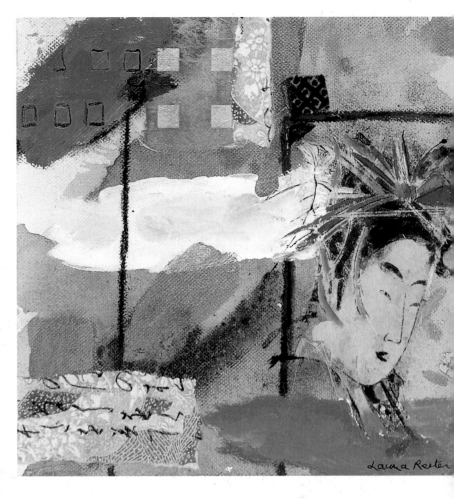

emerge from the simple beginnings of marks and colour, and how you can achieve exciting results by experimenting with a multitude of materials, allowing them to interact together to create new possibilities. These processes will, hopefully, open up a whole new world of painting to you.

◀ Tradition
mixed media on canvas
25 x 25 cm (10 x 10 in)
Indian handicrafts, traditionally made by women, inspired this colourful painting. The patterns are typical of those found on textiles, and both these and the leaf shapes extending across the centre of the painting have the look of embroidery or appliqué.

▲ Geisha
mixed media on canvas
20 x 20 cm (8 x 8 in)
I used more direct imagery in this painting, including collages of the face of a geisha, Japanese patterns and writing. I chose the colours just because I liked them but also because they give the painting a fresh feeling of spring – the time of year I visited Tokyo.

Materials and Equipment

Working in mixed media is an ideal way to express abstract ideas. It can help to expand visual possibilities, allowing abstract images to emerge, and it is also great fun to see materials reacting with and responding to each other. Water-based paints are ideal for this as they are versatile, dry quickly and work easily with dry materials such as pencils and pastels.

Watercolours

Watercolours are available in tubes and in pans of solid paint, both of which are fine to work with. The quality varies, from the more expensive artists' watercolours to the cheaper students' quality paints.

Brushes

Good watercolour brushes are the most important tool in watercolour painting and it is worth investing in two or three brushes in different sizes – a No.12, a No.16 and a generous wash brush make a useful trio. As well as real hair brushes, there are many effective brushes with synthetic fibres.

Palettes

Large plastic palettes with mixing areas and wells for mixing watery paint are ideal. Even an old saucer is suitable for mixing larger quantities of paint.

Paper

Watercolour paper is made specially for watercolour paint. I like Bockingford, which is an affordable paper. I use a heavyweight 638 gsm (300 lb) 'rough' paper, as it takes watery paint well and is strong and therefore suitable for mixed media work. However, lighter paper such as 300 gsm (140 lb) is fine if stretched on to a board to avoid 'cockling'. Smoother surfaces are known as 'hot-pressed', which is completely smooth, and 'cold-pressed' or 'Not', which has a fine-grained surface.

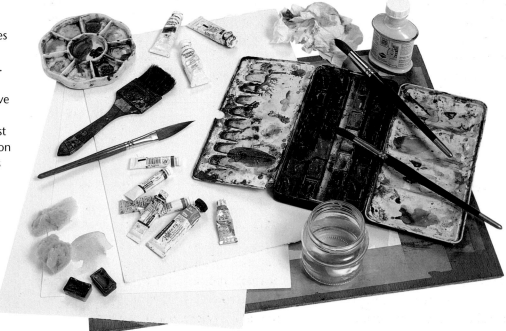

► A box of pan watercolours or tubes of watercolour give equally good results. I also use tubes of gouache paint to give a more solid colour effect. Create interest with a varied selection of brushes as well as materials such as natural sponges or masking fluid.

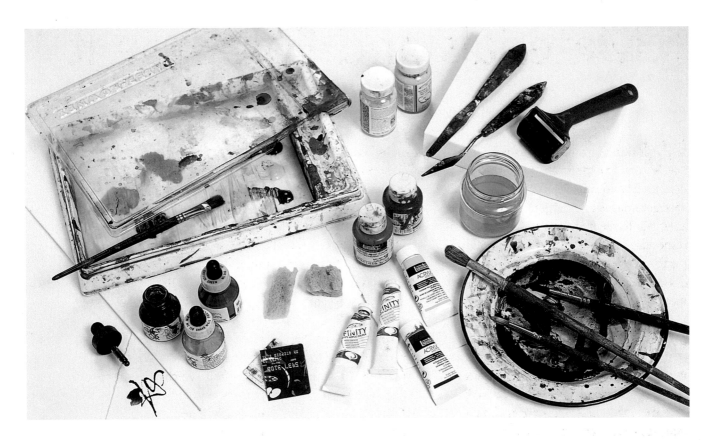

Acrylics

Acrylics are modern, water-based paints available in many different grades and colours. Their consistency varies according to the manufacturer, ranging from soft and flowing to thicker and more viscous. They come in tubes, small bottles with more intense pigments and also in liquid form as acrylic inks. Acrylics are very adaptable paints. You can use them well diluted like watercolour or thick like oils, or mix them to any consistency in between, and they can be applied and manipulated in many different ways.

Brushes and tools

I recommend synthetic brushes specially made for acrylic paints, although hog hair oil painting brushes are also suitable. Acrylics dry very quickly, so remember to wash your brushes after use or they will quickly be ruined. I usually rub my brushes with washing-up liquid or soap to remove any lingering paint, then rinse them in cold water. As well as brushes, you can use a variety of painting tools with acrylics, including palette knives, sponge rollers, natural sponge and even an old credit card.

Palettes

You have several options to choose from, including plastic watercolour palettes and tear-off palettes. One type of palette, made specially for acrylic painting, is a 'stay-wet' palette. The paint is mixed in a lidded tray on thin semi-permeable paper placed over wetted blotting-type paper. Because the tray can be made airtight, the paint remains moist. It is possible to create a homemade version from a plastic storage box with a lid, wet kitchen towels and baking paper.

Supports

Acrylics can be used on cartridge or watercolour paper, or on special paper made for acrylics, which has a more 'slippery' surface. You can also work on canvases, primed ready to use. Oil painting boards, available in many shapes and sizes, are also suitable for acrylics and are an economical alternative to canvas.

▲ Tubes and small bottles of acrylics with a selection of brushes, palette knives and other painting tools. A 'stay-wet' palette keeps the paint moist.

Dry materials

There are many dry materials that can be used in mixed media painting, including a wide range of pencils, pens, oil pastels and soft pastels. Different makes feel different in use and react in various ways to your painting surface and to other media. Try out some of each type so that you can find your own favourites to work with.

Pencils

Pencils come in varying degrees of texture from hard (marked with 'H' numbers) to soft ('B' numbers). The rule is that the higher the 'H' or 'B' number, the harder or softer the pencil will be (for example, 8H is a very hard pencil and 8B a very soft one). A collection from H to 6B is probably enough for you to make a varied range of marks.

Pens

Some pens are not strictly 'dry', but they fall into this category as they make essentially linear marks. There are many types of pen, from water-soluble or permanent marker pens to dip pens with nibs for use with bottled inks. Coloured felt-tipped pens are economical and even the humble biro can be a good tool.

Oil pastels

Oil pastels are available in a wide range of beautiful colours. They usually come in the form of solid, water-resistant sticks but there are also varieties of oil-based pastels and pencils that are water-soluble. Some of these are quite hard and are good for line drawing, while others are fairly soft and can easily be blended on the paper.

Soft and hard pastels

Like oil pastels, soft pastels and hard pastels come in sticks in myriad colours but they are chalk based. They are also available in pencil form for finer drawing. Soft pastels make smudgy marks that can be blended beautifully together, whereas hard pastels can also be used for finer lines. Pastels can be used on their sides to give veils of colour. Soft and hard pastels are not permanent and should be fixed with a special fixative spray to avoid smudging (although hairspray works almost as well).

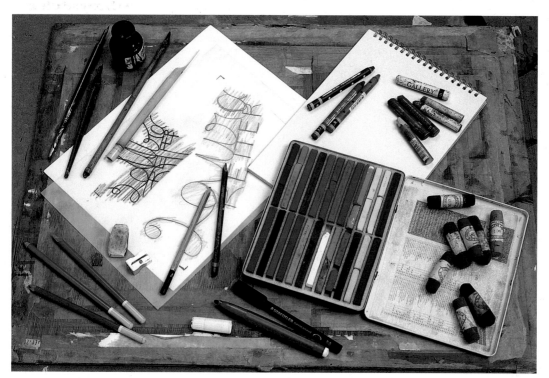

◀ Use dry materials to add detail and texture to your painting. Dip pens, marker pens and drawing pencils make different types of line, while soft and hard pastels, oil pastels and pastel pencils introduce coloured areas and marks.

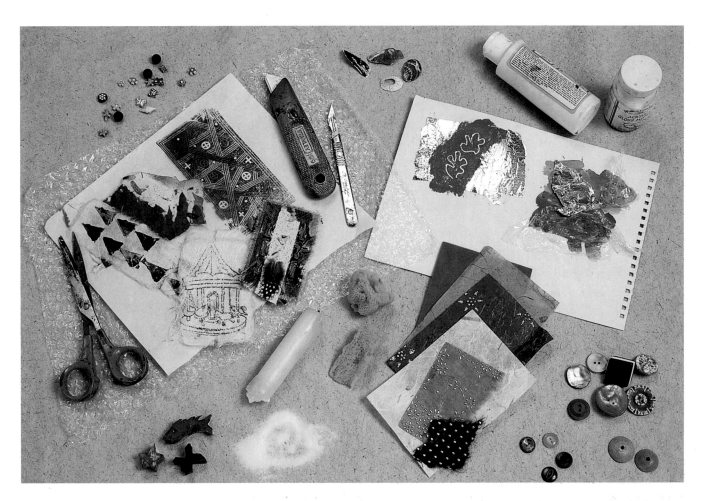

Extras

As well as the more obvious materials mentioned previously, there are many others that can be used for mixed media painting – some conventional, others less so. You will find it useful to gather together a selection of the following items to extend your repertoire of mark-making.

Firstly, a household candle rubbed over areas of your painting surface is a simple device for resisting paint and making a texture. Equally useful for creating texture with paint are salt (all kinds, including dishwasher salt) and acrylic texture mediums of different types. Then there is the trusty sponge, natural or manmade, for dabbing on paint. Bubblewrap and clingfilm are also good for imprinting textures onto paint, while rubber erasers, cut into shapes, make great stamps.

To change the surface of your paper and give a relief effect, use collage with silver foil, printed and textured papers, shells, buttons and anything else you can think of that will stick onto your painting. Finally, to prepare and apply these materials, you will need a pair of scissors, a craft or Stanley knife and some PVA glue.

▲ Some of the 'extras' that can be used for lively textural effects include coloured papers, tin foil, bubblewrap, buttons, sponges, a household candle, acrylic medium and salt. You will need scissors, craft knives and PVA glue for collage.

If you find it hard to see where you have applied colourless candle wax resist, hold the sheet of paper at eye level and look along the surface.

Using Colour

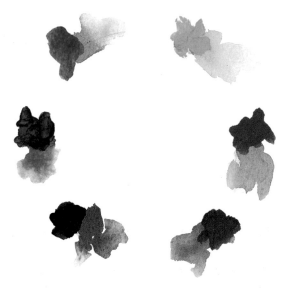

olour is a wonderful, descriptive, exciting, expressive, essential part of our world. It can be used in many ways when painting and is, of course, an integral part of this activity. However, to use it as effectively as possible, you need to know something about its properties and characteristics so that your paintings can benefit as much as possible.

Primaries and secondaries

The primary colours are red, yellow and blue, and these essentially form the basis of all colours. If you mix pairs of primaries together, you get three more colours – the secondary colours. Red and blue make purple; yellow and blue make green; and yellow and red make orange.

◀ The colour wheel shows the three primaries (red, yellow and blue) and the three secondaries achieved by mixing pairs of primaries together.

These six primary and secondary colours can be placed around a colour wheel (above). The colours in the wheel have various qualities and relationships with each other.

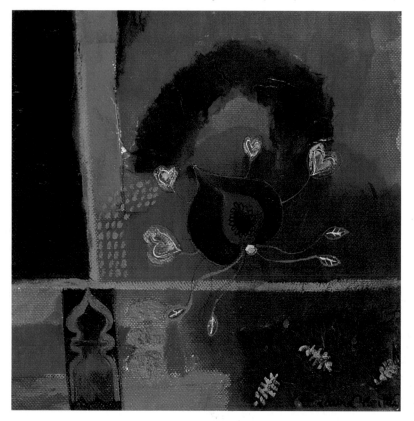

◀ My Heart Took Flight
mixed media on canvas
20 x 20 cm (8 x 8 in)
The colours and motifs used in this painting originate from those I saw during a trip to India. The bottom left-hand arch represents typical shapes seen in the architecture there. I used complementary colours to give a vibrant feeling to the painting.

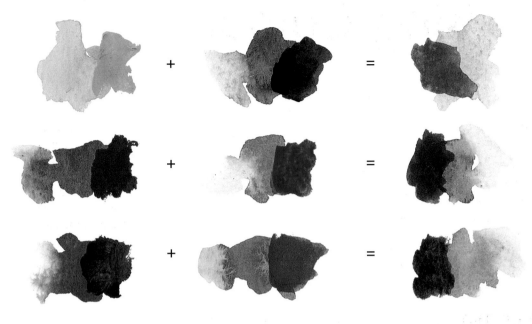

 ◀ Complementary colours (yellow/purple, red/green and blue/orange) mixed together in equal quantities produce neutrals (greys and browns).

They range from 'hot' colours (those with a red or orange bias) on one side of the wheel to 'cool' colours (those with a blue or green bias) on the other. When hot or cool colours are used in a painting, they can create a warm or cold atmosphere.

Colours near each other on the wheel are said to be harmonious. Those opposite or far away from each other are called contrasting colours.

Complementary colours

Colours directly opposite each other on the colour wheel can be thought of in pairs called complementary colours: red and green, yellow and purple, and blue and orange. When these colours are placed side by side,

they contrast very strongly or push each other away. When they are mixed together, however, they create another set of colours – the neutrals (greys and browns).

Adding black and white

As well as creating new colours by mixing primaries and secondaries, you can change colours by mixing in black or white. For example, mixing white with red makes pink, and mixing black with red makes maroon. This works well with acrylics but, in general, black and white are not used with watercolours. Mixing either black or white into watercolour can render the resulting colour opaque, and it will then tend to sit on top of the other, transparent, colours.

▼ The more black that is added to the green, the darker the shade of green becomes.

▶ Adding varying amounts of white to red creates a range of light and medium pink tints.

13

Mark-making Techniques

Every medium makes a different kind of mark. Marks in watercolours and acrylics are first and foremost made with a brush but can vary a great deal according to how the brush is used. There are also other ways to make marks with these paints, some of which are described below.

Watercolour

As watercolour is a transparent medium, colours and tones are built up by layering the paint. There are several ways to apply watercolour, each of which makes a different kind of mark.

Wet-in-wet wash

With this technique, very wet paint is applied to an area of paper that has been wetted with clean water. If you tilt or wiggle the paper, the paint will spread to create a beautiful, misty effect. Further colours touched into the wet wash will run into it, creating soft edges where they merge.

Wet-on-dry

By applying wet paint to dry paper, you can create shapes with crisp, hard edges. If you want to soften an edge, quickly paint along it with clean water on your brush.

Another way to make a soft edge is to use a technique that I call 'quite-wet-on-quite-wet'. Observe the amount of water in the wash on the paper. Once it has dried from shiny to a satiny sheen, it is neither very wet nor very dry and, at this point, you can add another colour to make marks with soft edges. If you notice that the second colour begins to spread out into the first wash, this means that the paint is too wet and the added colour may form a crinkled 'cauliflower' mark once it has dried.

Layering

When applying watercolour in layers, work from light colours to dark ones and make sure that each layer of watercolour is completely dry before applying the next. With layering, you can create different tones and give a sense of distance to your painting.

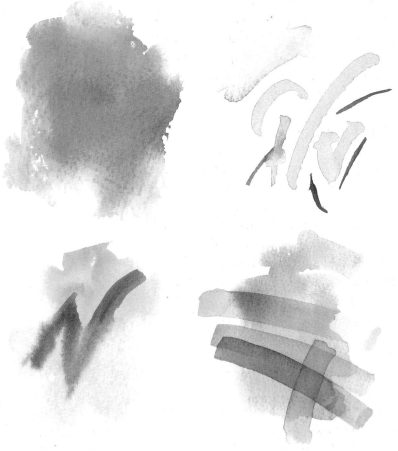

▼ Watery paint on a wet surface creates a misty, blurred effect. Further colours, added quickly, blend into the wash.

▼ Wet paint applied to dry paper makes well-defined shapes with hard edges. An edge can be softened with a swift brushstroke of clean water.

▲ When fairly wet paint is added to a dampened surface or partly dried wash, it produces shapes with soft edges.

▲ Layering a wet wash or brush mark over completely dry paint alters colours and creates tones.

14

Acrylics

Acrylics are versatile paints that can be used watery and transparent in a similar way to watercolours or thickly for an opaque finish. They can be applied with a variety of tools and mixed with materials such as sand, sawdust or texture gels to give a range of textured surfaces.

Making opaque marks

When used thickly, acrylic paint is capable of completely covering another colour. You can layer a pale colour over a dark one, even white over black. Vary the type of mark you make by using brushes of different shapes.

Using a palette knife

A palette knife is a great tool if you want to make flat or textured acrylic marks or spread a large amount of paint. You can also use a palette knife to lift areas of paint, but work swiftly as acrylics dry quickly. As with brushes, different shapes of palette knife make different marks.

Using a sponge

Applying acrylic paint with a sponge can create interesting chunky textures. Lightly touch some acrylic paint with a dry sponge and then, equally lightly, make marks on your surface with it. An open texture will be created. Be careful not to use too much paint or the holes in the sponge will become blocked and the open texture will be lost.

If you use a damp or wet sponge, you will create a more watery mark that looks similar to one made with watercolour.

Drawing into wet paint

You can make exciting linear marks by painting a layer of acrylic over an area of dry acrylic colour and then drawing into it immediately using a pointed implement such as a palette knife, a sharp stick or the end of a brush. The pointed tip removes the top layer of paint, revealing the contrasting colour underneath.

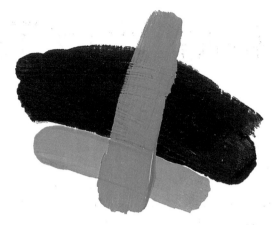

◀ A thick band of opaque green acrylic paint covers both the light and the dark acrylic underlayers equally effectively.

◀ A palette knife is useful for creating large areas of paint that can be smooth or textured.

◀ Used with neat or diluted paint, a sponge produces wonderful textured areas quickly.

◀ The bright blue underlayer is revealed when the top layer of paint is scratched away with the end of a pointed stick.

Other materials

The contrasting qualities of wet and dry materials can be used to good effect in abstract painting. Get the most out of your dry materials by experimenting with marks of all kinds, both linear and tonal.

Pencil

The softer B pencils make wider, darker marks and tend to smudge, whereas H pencils at the harder end of the range make thinner, more spidery marks. By using a pencil on its side instead of drawing with the tip, you can create shading or tonal marks. Light pressure produces subtle, pale grey shading, while pressing harder or working into an area creates darker tones.

Pen and ink

Different types of pen and shapes of nib make linear marks of different thicknesses. You can create interesting tonal effects with a technique known as 'crosshatching', in which one set of straight lines is crossed by another set drawn at an angle. The closer the lines, the darker the tone appears to be. Some pen lines can be softened with water. Indian ink, for example, can be diluted into a wash but will be permanent once dry. Lines made with non-permanent marker pens can also be softened with water but will remain water-soluble. Permanent markers, however, are not water-soluble.

▶ These lines were drawn with a 4B pencil, pressing harder to make the darker marks.

◀ A soft 6B pencil was used on its side with varying degrees of pressure for dark and light shading.

▶ Line drawing with pen and ink includes an area of crosshatching to create tone.

▶ These pen and ink lines were softened with water. The marks were applied with a pen and then a wet brush was dragged lightly along one side to dilute this edge.

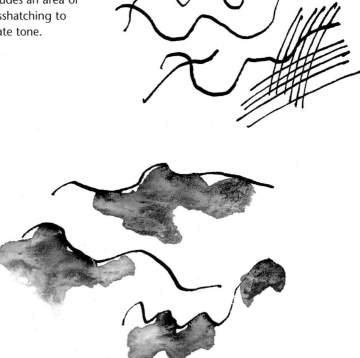

Oil pastel

You can make many different marks with oil pastel, although once it is on the paper, it is difficult to remove. Lovely strong colour can be blended on the paper and then drawn into with a hard edge or point, such as a palette knife blade or a sharp stick.

▶ Different colours of oil pastel are blended on the paper, then shapes or patterns drawn into the pastel with the end of a paintbrush or other pointed implement.

▶ Oil pastels applied with short, stabbing strokes create dots of colour that can appear to blend together – a technique known as optical mixing.

Soft pastel

Depending on whether soft pastels are applied using their point or on their side, they can make linear marks or broad areas of colour. They can be mixed on the paper by gently rubbing the colours together or by layering one tint on top of another, using small marks or broken areas that will reveal some of the colours underneath. Remember that soft pastels must be fixed with a fixative spray or hairspray to avoid smudging.

▶ Applied on its side, soft pastel creates areas of colour. When used with the tip, it gives more detailed, linear marks.

▲ Blend different colours of soft pastel so that they blur gently together to create new hues.

17

Creating texture

There are many ways to create textures with paint. You can change the surface of the paper before applying the paint, using resist methods or texture gels. Alternatively, you can alter the appearance of the paint once it is on the paper. Some tried and tested possibilities follow but experiment with your own ideas, too, as you may find a way to create just the effect you want.

Salt

Any kind of household salt will do for this textural effect, even the dishwasher variety. Sprinkle the salt into an area of wet watercolour. The salt absorbs the solution of watery paint and, as the paint dries, lighter, mottled areas appear on the paper.

Candle wax resist

Make firm marks on the paper with an ordinary white household candle and paint a wash of watercolour or thin acrylic on top. The candle wax will resist the paint and show through as a clear mark that will remain permanently on the paper. Marks made with oil pastel have a similar effect.

Clingfilm and bubblewrap

Carefully place a piece of clingfilm or bubblewrap on top of an area of wet paint. Press it down gently and leave it in place until the paint has dried completely. When you slowly remove the clingfilm or bubblewrap, a beautiful texture will be imprinted on the paint.

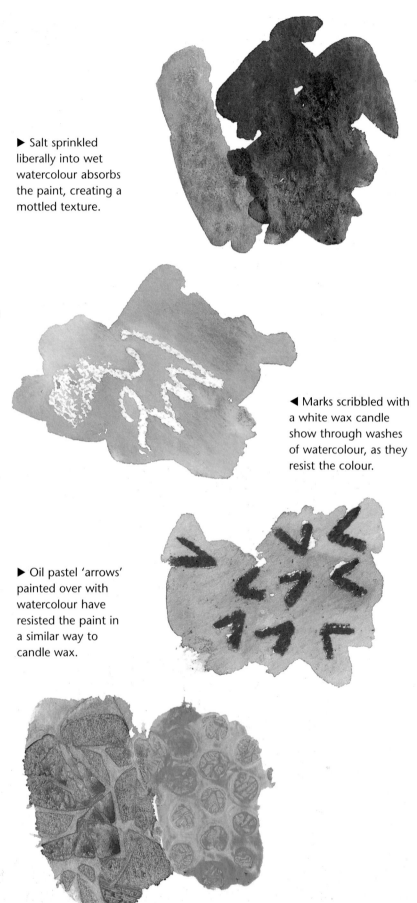

▶ Salt sprinkled liberally into wet watercolour absorbs the paint, creating a mottled texture.

◀ Marks scribbled with a white wax candle show through washes of watercolour, as they resist the colour.

▶ Oil pastel 'arrows' painted over with watercolour have resisted the paint in a similar way to candle wax.

▶ These textures were created by placing clingfilm (left) and bubblewrap (right) over areas of strong acrylic colours and removing them once the paint was dry.

Scraping with card

This is a good method of creating texture with acrylic paint. Achieve broad, uneven effects to cover large areas by using the edge of a piece of stiff card to move the paint around. Leave slightly raised lines of paint by lifting the card before all the paint has been spread. You can also print lines by dipping just the edge of the card into paint and lightly placing the edge onto the paper.

◀ Here, acrylic paint was scraped over the painting surface with a piece of stiff card, spreading the colour unevenly. Lines of paint were printed with the card's edge.

Texture gels

There are various types of texture gel available in small bottles, each producing a different finish. These include fibrous textures of varying thicknesses, a glass bead texture consisting of tiny beads suspended in the gel, and my favourite, 'natural sand', which has a regular, rough texture. You can apply the gels to your support with a palette knife, a brush or even your fingers. Once dry, the gels create new surfaces ready to be painted over with acrylics or watercolours.

▶ In these three examples, acrylic gels were applied to the surface of the support. I drew a pattern into the one on the left while it was still wet. For the other two examples, I used a medium-textured fibrous effect and 'natural sand'.

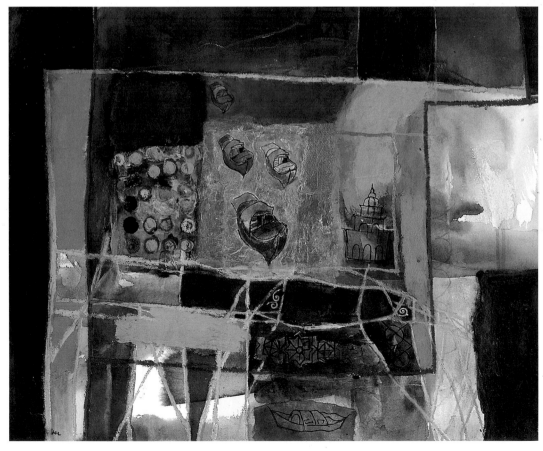

◀ **Along the Perfumed River**
mixed media on paper
50 x 63 cm (18 x 25 in)
Beautiful pagodas, quirky bridges and fishing boats were all memorable sights of a trip to Vietnam. In this painting I used oil pastel extensively as a resist, not only in the lines dividing different areas but also to describe the bamboo bridge shape along the bottom and the decorative circular patterns above it.

Working with Collage

In earlier chapters we looked at a range of painting and drawing materials, sometimes used alone, sometimes together, but always applied directly onto the painting surface. In this chapter we are going to find out how to change the surface itself by adding collage. The art of collage began centuries ago in countries such as Japan, Africa and Persia, where it became part of their ethnic traditions. It became accepted into Western fine art only in the twentieth century.

What do you need for collage?

The first thing to do is become a collector of materials – anything and everything is potentially useful for collage. These include photographic images from magazine or newspaper cuttings, and papers of all kinds from textured, coloured, tissue and handmade papers to silver foil and even recycled scraps from abandoned paintings. Small objects, such as beads or nuts and bolts, can also be used for interesting three-dimensional textural surfaces.

How is collage applied?

White glues such as PVA are the most versatile and dependable for collage, as they are water-soluble and dry transparent. There are also many useful acrylic-based mediums, such as acrylic matte medium, that you can buy in tubes or pots. These are produced specifically for creating textures but they can also be used as an adhesive.

Getting started

Experiment by making yourself a 'collage map' to get ideas for a range of effects. Gather together as many different kinds of materials as you can. Use white glue either neat or, for more delicate materials, diluted (about half glue, half water). Now take a large sheet of paper and try out some of the following suggestions. Remember to write some notes about how you achieved each one, as it is easy to forget how you got there – and very annoying when the technique you have forgotten is just the effect you need in a particular painting!

- Crumple some white tissue paper. (Note that coloured tissue paper will fade or run when in contact with water). Stick it down and then paint over the top with watercolour. You can repeat this in layers, using different colours.
- Try making a 'mosaic' design with coloured paper. Cut or tear small pieces of paper and apply them in a regular pattern

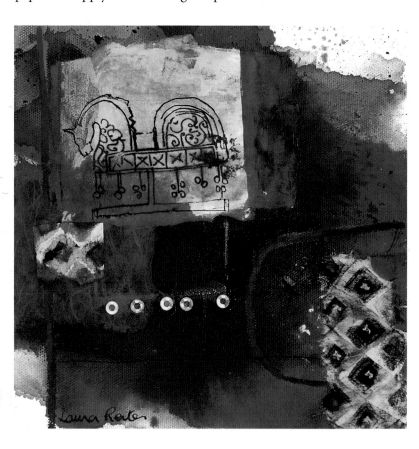

▼ **Horseplay**
mixed media on canvas
20 x 20 cm (8 x 8 in)
The wooden horse is an ornament I found in a shop in London. It is Indonesian in origin. I loved the shape and form of it and the collaged image shown here was transferred on to a piece of handmade paper from a line drawing. As well as pattern and colour, I've used small crystal beads as surface decoration.

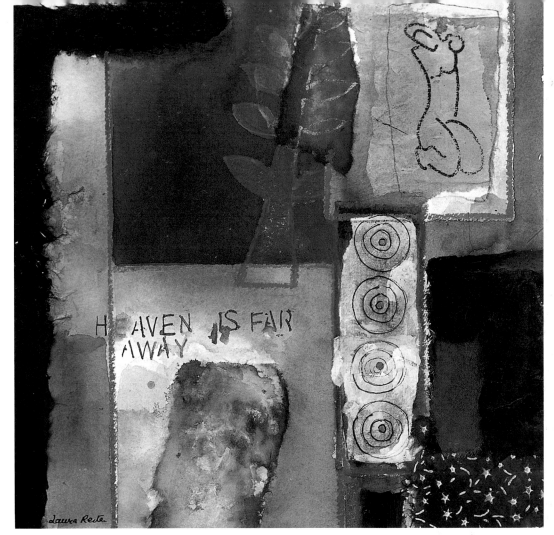

◀ **Heaven Is Far Away**
mixed media on paper
28 x 28 cm (11 x 11 in)
On a recent visit to
South Africa, I came
across some information
about Bush artists who
have rediscovered their
art. The figure is a line
drawing of a wood
sculpture and the title
is a quotation from
one of these artists.

▼ **Boudoir**
mixed media on canvas
20 x 20 cm (8 x 8 in)
The collaged lady is a
printed image and all
other elements of the
painting reflect her.
These include crystal
beads, patterned and
embossed paper
and a line drawing
of her mirror.

or in an uneven way to create either an
organized or more random composition.

● Apply some modelling paste or gesso
to the surface of the paper. Make a texture
with a palette knife, the end of a brush
or any other tool. Allow the paste to dry
thoroughly and then apply different paints
on top. Notice the different effect each type
of paint makes.

● Try rubbing across the painted, modelled
surface with soft pastels or oil pastels,
remembering to fix soft pastels with fixative
to prevent them from smudging.

● Find as many different materials as you
can. Tear them, cut them, stick them, draw
and paint over them, layer them and use
water-resistant oil pastels with them.

In short, be as experimental as possible
to get the most out of collage. Expand your
collage repertoire, so that when you begin
to make abstract paintings, you will have
plenty of ideas at your fingertips.

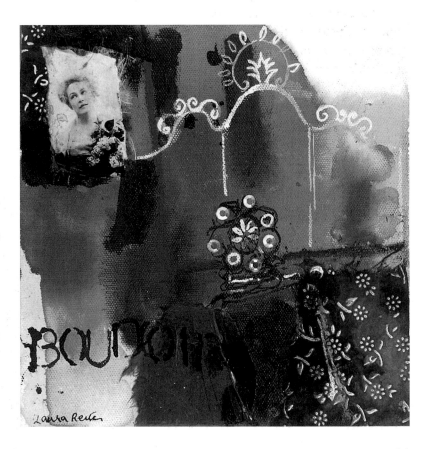

Design and Composition

Any painting you make – be it figurative or abstract – is an act of design. You are creating a set of marks, colours and shapes that have a relationship to each other within a little 'world' that is the painting. It is an act of problem solving that you can perform both instinctively and with conscious intent.

In abstract art, design is all the more important because its elements and the ways in which they are organized are the subject of the painting. A useful set of rules, known as the 'elements and principles of design', explains how to use design to convey your ideas in your painting.

The elements of design

Take a look at the various elements of design described here. They are the tools with which you construct your picture and the design fundamentals that make your paintings work.

Line
Used to create boundaries, lines can be thick or thin, wavy or straight, jagged or calm, descriptive or decorative. They can divide or connect, and help to move the eye around a painting. Lines can also express mood or emotion – a jagged line can describe aggression and anger, whereas a curved line feels slow and lyrical.

Shape
Shapes are essentially flat elements and range from the geometric, such as squares, circles and triangles to the organic, such as leaves, shells and trees. In a painting, there should be a variety of shapes. They can be created by painting the actual 'positive' shapes, or by painting the spaces around them, which are called 'negative' shapes.

◄ Thick and thin lines are made with wet, dry and collaged materials.

◄ These flat shapes are created with texture gel to give them 'body'.

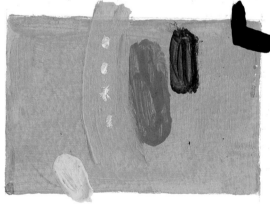

◄ The values here range from very light (white) to very dark (black) with a range of blue-green tones in between.

Value
You can create a sense of space in a painting by using value, which describes tone, or light and dark. With tone, shapes can be made to look like three-dimensional forms. For example, a circle becomes a sphere and a triangle becomes a cone. Tones range from white, through grey or different tints and shades of colour, to black. Strong tonal contrasts give a visual strength, while closer values create a lighter mood.

Colour

One of the most expressive elements in design, colour is the 'icing on the cake'. It can be intense or muted, and as it can express temperature, emotion and mood, it is especially useful in abstract work. Take descriptive phrases as a cue for using colour, as in 'purple with rage' to express anger or 'blue mood' to express sadness. Convey a happy mood by using bright reds, pinks, oranges or yellows to give the feeling of, say, a hot, sunny day.

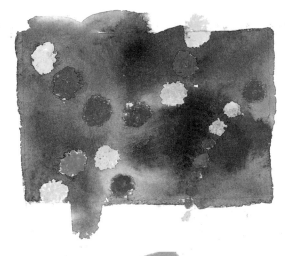

◄ The little 'blobs' in bright contrasting colours dance happily around the painting.

Size

Varying the size or scale in a painting is important in achieving an interesting composition. The relationships between small, medium and large marks or shapes help to add impact to the overall design. Proportion refers to size relationships to the whole. In realistic painting, correct proportions are essential, but in abstract work proportion can be used in any way you like to create the effect you want.

◄ Although the blue areas are much larger, the contrasting colour and scale of the little pink squares make them more important.

Pattern

Using the other design elements in a repetitive way creates decorative or descriptive patterns. You can build up pattern from a regular or irregular set of lines or shapes, such as zigzags or circles, or describe a surface or form by using appropriate textural marks. A wealth of ideas for patterns can be found both in the natural world and in industrial and manmade environments.

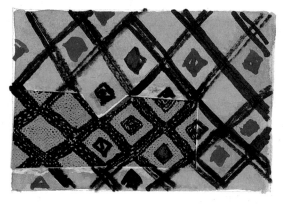

◄ A loosely regular diamond pattern is built up with paint and collage.

Movement

Movement in a painting helps direct the viewer's eye around the composition and controls the speed of this journey. A horizontal or flat movement is calm and restful, while vertical shapes or lines act as a stabilising influence or imply growth. Oblique movement is dynamic, suggesting energetic action as in crashing waves or windswept trees. A strong static mark can help to slow down an erratic composition.

◄ Watercolour and oil pastel are used here to convey a lively diagonal movement across the painting.

The principles of design

The design principles outlined below will help you use and combine the elements described on the previous pages effectively. Concepts such as harmony, contrast, rhythm and repetition impose order on the colours and shapes you choose and enable you to organize the structure of your painting so that it will convey its subject or intended message as clearly as possible.

Don't try to combine too many design elements and principles into a single painting, as the composition can become confusing and lack focus.

Harmony

A harmonious picture is one in which emphasis is placed on the similarities between colours, shapes, lines and sizes. The more similar elements there are in a painting, the more harmonious it will be. To achieve this effect, choose colours that are adjacent to each other on the colour wheel, such as blues and purples. Also use related shapes and lines or close tonal values to convey a feeling of serenity.

◀ Harmonious colours, such as these blues and mauves, convey a sense of tranquillity and calm.

Contrast

The exact opposite of harmony, contrast surprises the eye, contributes excitement and tension, and relieves monotony. These qualities can be achieved by using a number of devices. For example, complementary colours (those opposite each other on the colour wheel) push away from each other, injecting energy into a painting. Other 'opposites', such as straight and curved lines, jagged and smooth outlines or warm and cool colours, have a similar effect.

◀ Contrasting or complementary colours, used together with bold collage shapes, create an exciting image.

Rhythm

As in music, rhythm in painting is about pace and flow, and it influences the kind of journey the viewer makes across the composition. Related elements are repeated at intervals, depending on the speed at which the artist wishes the viewer to travel. The eye will move quickly if the elements are closely spaced or more slowly if they have larger intervals between them that allow the eye to pause for a rest.

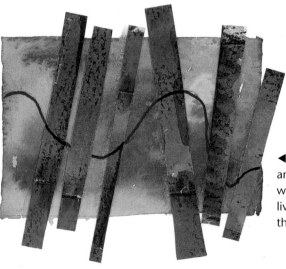

◀ The collaged strips and a unifying red wavy line provide a lively journey across the painting.

Repetition

As with rhythm, repetition provides movement across a painting. Repeated marks, lines, shapes, colours or tones can act as 'arrows' that direct the viewer's eye. For example, if a painting has bright red marks repeated in three places (perhaps describing a triangle), the eye will follow them, drawing an imaginary triangle in the process. You can avoid boredom by introducing variations of repeated elements.

◄ Repetition of the circular shapes, although they are different in size, guides the eye diagonally upwards and then back around the painting.

Gradation

Gradation in colour or line provides a gradual form of movement. Colours can be graded from light to dark, bright to muted or warm to cool. Lines can go from thick to thin and back again. Gradation in size or scale can give a sense of deep space or perspective. You can unify contrasting areas in a painting by making a gradual transition between them or make dull areas more exciting with gradations of tone or colour.

◄ Graded tones of purple, from very dark to very pale, guide the eye slowly down from top to bottom of the image.

Dominance

The dominant element in a composition is what the picture is really about. It is the star of the show. To draw attention to this element, make sure that it is more important than anything else in the picture. In abstract art it could be a larger shape, a repeated motif or a colour that outshines the others. This dominant feature is known as the focal point and should support the theme of your painting.

◄ The small red and blue shapes take up a lesser proportion of the overall composition. But because of their dominant appearance, the eye is immediately drawn to them.

Balance

Often an intuitive aspect of picture making, balance is about all the 'jigsaw pieces' of your painting living comfortably together in equilibrium. Whether the elements in a painting are distributed more or less evenly, or arranged asymmetrically, the final composition should look visually balanced. By constantly evaluating your painting, you should eventually come to a point where all the elements 'feel' right, and that is when your painting will be finished.

◄ This painting is supported by an underlayer of blues. The red lines and purple shapes are balanced in weight and cling comfortably to the edges of the picture to create a pleasing visual effect.

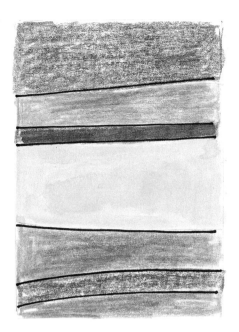

▲ A striped (or strata) format can imply a landscape or suggest layering in a more metaphorical sense.

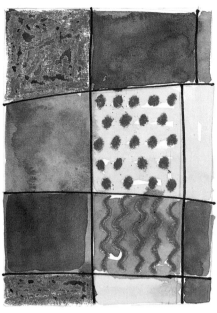

▲ A grid format can be even or uneven and could have symbols or shapes painted within the rectangles created.

▲ Place a horizon high or low in your painting but never in the middle, as this is confusing and rather boring.

Composition shapes

Composition is the activity of designing the overall plan or format of a painting. Some of the most useful compositional formats are shown here, with simple diagrams that describe their main characteristics.

Strata or striped format

With this format, the painting is divided into strips of varying widths. In abstract painting, the format can imply landscape, both above and below the surface of the earth, but can also give a sense of layering, both real and metaphorical.

Grid format

A grid format divides the painting into even or uneven rectangular spaces. The picture could focus on the treatment of the rectangles themselves, or the spaces could contain symbols or shapes describing a 'story'.

Low/high horizon

Whether a painting has a landscape (horizontal) shape or a portrait (vertical) shape, a horizontal line dividing the painting describes a horizon, which can be real or metaphorical. If placed high up in the picture, it gives a sense of climbing and height. If low down, it allows the space above to 'breathe'. The one place you don't want the horizon is right across the middle of the picture area – this cuts your painting in half and is confusing to the eye.

▼ Made in Mysore
mixed media on paper
45 x 45 cm (18 x 18 in)
Drawn lines and areas of collage divide this painting into a series of uneven, overlapping rectangles that create a complex grid.

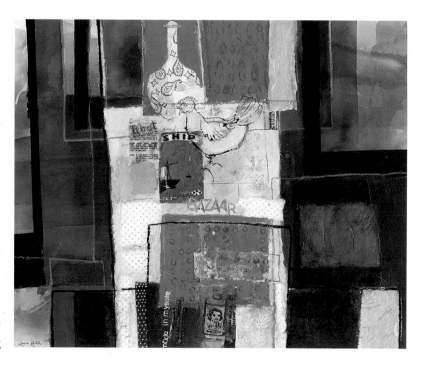

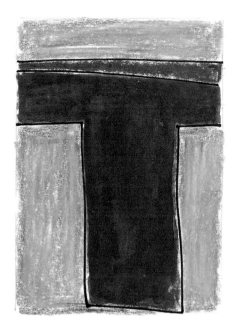

▲ A cruciform format holds the main interest and focus of a painting within a distinctive cross shape.

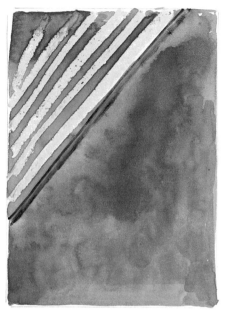

▲ Using a diagonal format is an effective way of giving a sense of dynamic movement across a picture.

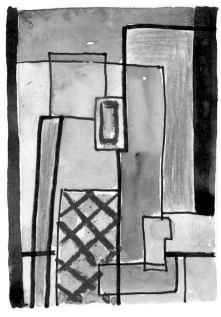

▲ Overall patterning allows all the elements within a painting to weave together to create the whole.

Cruciform format

This is a very useful format. The picture is divided by using a cross, or cruciform, shape with the centre of interest on the intersection. The arms of the cross should be placed either high or low on the picture plane. A cruciform format leads the eye upwards and outwards and holds the rest of the painting in place.

Diagonal format

A diagonal in a composition creates a dynamic and exciting painting with a sense of lively movement. A number of diagonals can be incorporated into a painting. Be careful, however, not to let the viewer's eye fly out of the picture area – a diagonal movement needs another strategically placed element to bring the viewer's eye back around the composition.

Overall patterning

The colours, shapes and lines in this format all weave together to create the whole. There should be unity within this kind of painting but there is often no real focal point. This is a difficult composition to achieve, as there must be balance without uniformity.

▼ 'I Must Draw Because…'
mixed media on paper
56 x 56 cm (22 x 22 in)
A 'cruciform' shape is created here by the wide red band across the middle and the lighter vertical one crossing it. Almost all the activity of the painting is taking place within this cross shape.

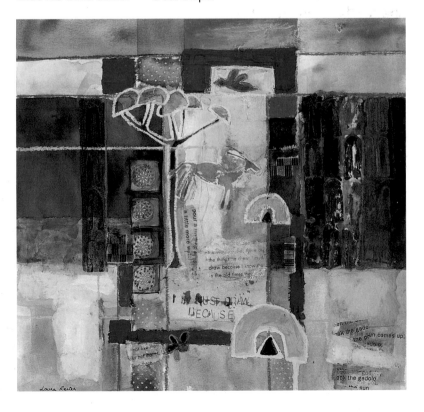

Making a Start

There are many ways to begin an abstract painting and the next few chapters will explore some of these. We will be looking at a variety of starting-off points and finding ways to simplify, manipulate, modify and distort the initial images.

Beginning with a doodle

The starting-off point for this chapter is a doodle. A doodle is, by its very nature, an unconscious act, an automatic drawing. It can take the form of anything from simple patterns to lettering or even figures or faces.

Take a reasonably large sheet of paper (at least A3 size), as you'll need the space to express yourself for this one! Begin to draw. Try to let the pencil travel as if it had legs of its own. Relax into the work, making curved and straight lines. Let some lines be long and others short. These lines should begin to make shapes, which will be dealt with at the next stage. Try to cover the whole page with your doodle – you should end up with a variety of different-sized shapes.

Filling the shapes

Now gather all your materials and begin to fill the shapes with colour, pattern and texture. Thicken lines, add colour to them and perhaps use collage to change some of the shapes. Anything goes. The main thing is to let the picture develop gradually, in an organic fashion.

Once you have covered a substantial area, think about making your emerging picture work as a finished painting. You could continue by simply developing the shapes, colours and lines, or you could think of a descriptive word or theme to help you decide the direction you want your painting to take. I noticed the 'loop' element in my

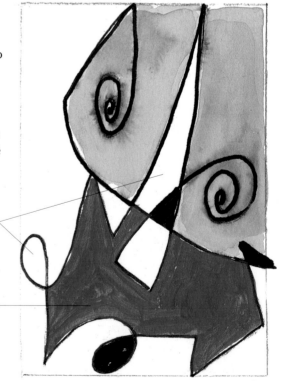

◄ Here, I reinforced my initial doodle with a black marker pen. Then I 'carved' a space out of the rectangle with green watercolour and filled in a few small spaces with the marker.

watercolour wash

lines reinforced with black marker pen

shapes filled with black marker pen

▶ I partly filled a tall triangle and small 'teardrop' shape with pink oil pastel ready to resist a watercolour wash at the next stage. I used green-grey opaque gouache to fill a space that was a similar weight to the green watercolour space above it.

oil pastel used as resist

opaque gouache colour

doodle and kept it as an important motif within the work. Don't add anything from now on until you have decided that it will work, and remember that you could leave some shapes completely untouched. Your thinking process should be more intense as the picture develops. Continue until the painting feels balanced and complete. It need not refer to anything real – it can be an expressive piece that exists on its own merit.

◀ **Loop-the-Loop**
mixed media on paper
42 x 30 cm
(16½ x 12 in)
In the final painting, brown watercolour fills the surrounding areas, revealing a pink colour where the oil pastel has resisted the paint. I lifted the rather heavy green-grey space with blue stripes made with a marker pen, which also fills a small triangle. The central rectangle is a collage of blue paper, and I introduced blue into the green watercolour.

pink oil pastel resist with brown watercolour wash

collaged blue paper

patterned area on top of opaque paint, made using marker pen

Using your name

The idea of using the random lines of a doodle to suggest an abstract painting can be extended by using the letters of your name, which will not only give you some strong and varied shapes to work with but will also feel very personal.

Writing your name

Take a large sheet of paper and write your first name diagonally across the page in pencil. Now add your surname in block capitals directly underneath. This will give you the chance to make plenty of different shapes. Extend some of these letters to the edge of the paper, letting the lines cross over each other. Many new shapes will be created once you have done this.

Creating a new image

Begin to fill some of the spaces you have made, using colour, texture and pattern in a variety of mediums just as you did with your doodle. I used a combination of oil pastel, coloured paper collage and coloured pencil with gouache and watercolour paints. Oil pastel and collage are both strong mediums that begin to dominate and let your picture change and grow. Gradually, your name should disappear and another image start to emerge.

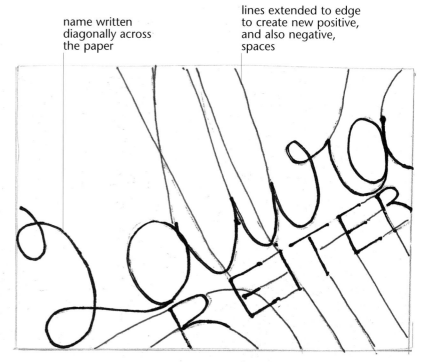

name written diagonally across the paper

lines extended to edge to create new positive, and also negative, spaces

▲ I wrote my name boldly in script and upper case diagonally across the page. Using a red pen, I extended lines from the letters right out to the edges of the paper, making some of them curved and others straight. In this way, I formed some unexpected new shapes.

▼ I reinforced the flowing lines of 'Laura' with a purple oil pastel. Then I chose some of the shapes I had created in the previous step and filled them in, using a flat application of blue gouache paint.

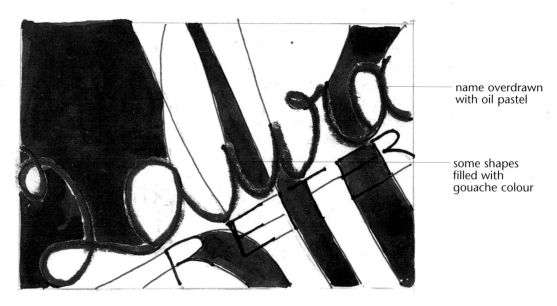

name overdrawn with oil pastel

some shapes filled with gouache colour

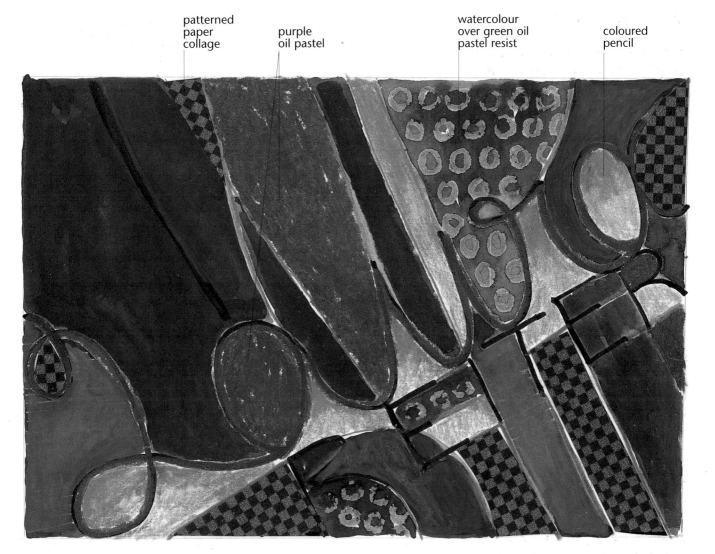

patterned
paper
collage

purple
oil pastel

watercolour
over green oil
pastel resist

coloured
pencil

**▲ Squares and Circles,
Circles and Squares**
mixed media on paper
15 x 22 cm (6 x 8½ in)
Finally, I added some
patterned paper
collage, coloured other
areas with purple oil
pastel and gradated
orange pencil, and
drew circles in green
oil pastel. I painted
purple watercolour
over the oil pastel
circles, which resisted
the paint.

Responding to the changes

As you work, look at each shape and space
as part of the whole painting, making
decisions about light and dark tones and
transparent and opaque areas accordingly.
Keep a constant eye on how the picture is
developing and allow yourself to respond to
it each time it changes. Patterned paper and
oil pastel resist will dominate over flatter
areas. By using these materials, your
composition can emerge more clearly. Let
the picture 'talk' to you. Try to really see
what each area and then the whole
composition looks like, responding at each
stage until you feel that there is nothing else
to do and the painting looks finished.

To help 'lose' the
letters of your name
within the painting,
use colours that are
close in tone.

Developing a Natural Form

All natural objects have different characteristics. For example, a bunch of grapes can be seen as a collection of small spheres held together by tiny cylindrical stalks to form a pyramid shape. By taking each quality of a natural form and describing it in various experimental ways, you can explore it in the abstract.

Exploring abstract qualities

Georgia O'Keeffe (1887-1986), the American avant-garde artist, said, 'Sometimes I start in a very realistic fashion, and as I go from one painting on to another of the same kind, it becomes simplified till it can be nothing but abstraction…'

Our next step in the journey to abstraction is to start, like Georgia O'Keefe, with a natural object – in this case, a strawberry – and begin to explore its qualities and the space it occupies within the rectangle of the picture. Then we'll try some experimental treatments of the object.

Try out the ideas shown here and then think of other ways to describe the qualities of the object. For example, you could use more than one technique or medium, perhaps oil pastel resist with watercolour, or paint with pen and ink. Try out as many permutations as possible.

Tonal drawing
The first thing to do is to make a good tonal drawing of your chosen object, as this will give your eye a chance to get to know it in detail and discover a sense of its unique three-dimensional form.

Silhouettes
By tracing your first drawing, the two-dimensional shape of the object is revealed. Place it in a rectangle and paint it in a flat colour to show it as a positive shape. Repeat

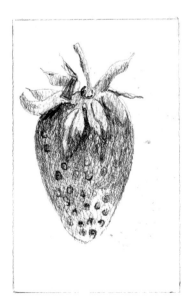

▲ A tonal drawing made in pencil describes the strawberry's form. As it is lit from below, a highlight appears on the tip.

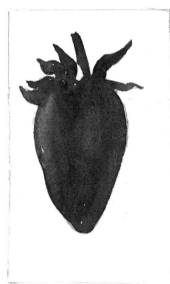

▲ The traced outline of the strawberry from the previous drawing is filled in as a flat, positive shape.

▲ This time, the area surrounding the tracing is filled in to show the negative shape around the strawberry.

▶ A marker pen is used to make a simple line drawing of the strawberry, showing its main features and the areas of light and shade.

▶ (centre) The main tonal areas of the strawberry, lit here from above, are outlined and then filled in with flat gouache paint.

▲ The colour of the strawberry and the spotted pattern on its surface are explored and simplified.

this process with another tracing, again placed within a rectangle. This time, apply paint outside the edges of the tracing – the painted area is a negative shape.

Line drawing

A line drawing gives us more information. Here, the line drawing shows not only the outer shape of the fruit but also the leaves, texture and lines indicating the shadow shapes. Although it leaves out tonal shading, there is a sense of three dimensions.

Simplified tone

Another interesting experiment is to describe the three-dimensional form of your object in a simplified way. Select the essential areas of tone that describe its form and paint these shapes using appropriate light and dark colours.

Simplified pattern

Now focus on the decorative nature of the object. Search for, and simplify, the patterns and surface textures and then use colour to enhance them. By now, you should be getting to know your object really well!

Experimental colour

Having investigated some of the main qualities of your object, now is the time to be a little more inventive. Try experimenting

with unrealistic colour to see how you can employ a more personal vision by changing the character of the object. Be as adventurous as you like.

Contour drawing

If you slowly stroke your fingers over the surface of an object, you can feel how it curves, undulates and changes direction. Try to describe this changing surface by drawing closely placed contour lines that follow the form.

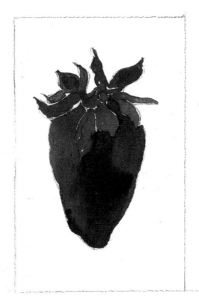

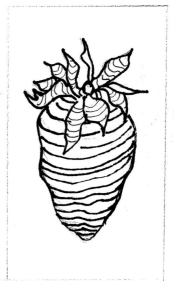

▲ Unrealistic, strong colour is used experimentally here to give a personal interpretation to the strawberry.

▲ A contour drawing using marker pen describes the surface of the strawberry and its leaves.

Variations on a theme

On the last two pages, we looked at how you could investigate a natural form (the strawberry) by exploring its qualities and characteristics. Here, you will discover how you can develop this idea further by using objects more creatively to make paintings.

A single object can provide enough information to begin an abstract painting. Choose an object that interests you and perhaps make an exploratory drawing. Then gather together a variety of materials to use. Now you are ready to investigate the possibilities of using this object in an abstract way. Work quite small – these are just ideas for a final piece.

Imaginary colours

The first experiment is to investigate colour, using a representational line drawing as a starting point. You could focus on the realistic colour of the object but a more effective way to change and abstract from

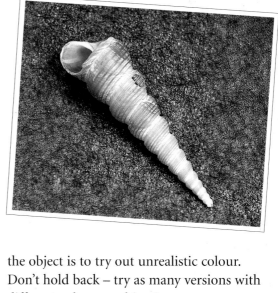

◀ Photo of shell

the object is to try out unrealistic colour. Don't hold back – try as many versions with different colour combinations as you can. What you finally choose will be a very personal vision.

Extending lines

Draw your object again but, this time, extend some of the lines to the edge of the page. This immediately disguises the

▼ Focusing on the spirals once again, I lengthened the curved lines to the edge of the paper and reinforced them with black ink. Then I used opaque colour and simple pattern to fill the shapes.

▶ Here, the focus is on the spiral shape of the shell and the use of unrealistic colour. I used masking fluid as a resist, over an initial blue wash, to protect the lines of the spirals. I then painted layers of watercolour washes over the top. Once they were dry, I removed the masking fluid to reveal the blue lines.

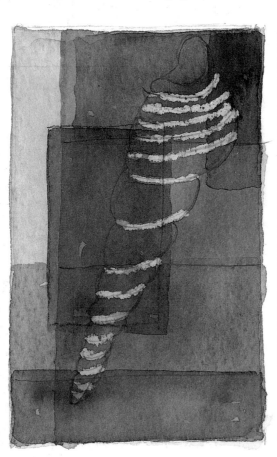

original shape and creates another set of shapes, which you can then paint in a range of colours, adding pattern, texture and line. Different treatments of the shapes will change the overall effect. For example, lighter shapes come forward, while darker ones recede. Try repeating the original drawing and changing the way you fill the shapes to see what effect this has on the overall composition.

Repeating and mirroring
There is no need to use your object only once. By repeating it several times, you will create more areas related to the edge of the page. You can do this in various ways. Overlap the shape many times, repeat it in different sizes across the paper, use mirror images as I have or repeat the image the same way round, attaching the shapes to form a chain across the page.

Creating a final piece
Making investigations of this sort will stand you in good stead, as you can use them as a resource to build up ideas for a larger painting. Take a look at your experiments and select the ones that appeal most. Now try to use some or all of these in a final painting, remembering to leave space for new ideas to emerge as you go along.

◄ The shell motif is repeated here as two halves and two wholes, which are mirrored. I used coloured pencil and watercolour on the shell and background and again emphasized some of the spirals with pen and ink.

▶ **Climb the Spiral**
mixed media on paper
21 x 15 cm (8¼ x 6 in)
From the previous trial ideas I chose the 'layering' method in watercolour, using tonal differences to give a sense of space. Opaque marks in gouache sit on top of these shapes, together with some lines picked out in black marker pen.

Altering Shapes

There are many different routes towards abstraction. In the previous chapter we saw how single objects could be investigated and developed. This time, we are going to look at how a few objects, set up as a still life, can be altered in another way, based on changing and simplifying their forms in a geometric way.

The French Post-Impressionist painter, Paul Cézanne (1839-1906), believed that all forms could be seen as cubes, triangles, cylinders and spheres. Many paintings by members of the Cubist movement, such as Pablo Picasso (1881-1973) and Georges Braque (1882-1963), portray still life groups and other subject matter as a series of geometric forms and lines that have the effect of flattening the pictorial space.

Setting up a still life

To try this for yourself, first set up a group of interesting objects. Carefully consider where each one sits, making sure that some of them overlap others – they should not all stand in a row. Place the objects on a piece of material or other interesting surface. Remember that the surface in a still life is an object in itself.

Making a tonal drawing

When you are completely happy with the placement of the objects in your still life, make a tonal drawing of the set-up in pencil. Put in plenty of information, as this will come in useful later. Remember to observe the shadows cast on the surface on which the objects are sitting as well as those on the objects themselves. These cast shadows create additional shapes to give interest to the composition.

▶ Taking a photo of the still life set-up ensures that, if necessary, it will be easy to set it up again exactly the same as before.

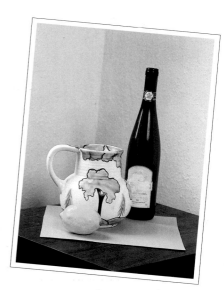

▼ A good tonal drawing is the first step. Remember to draw in the shadows on the horizontal surface as well as those on the objects themselves.

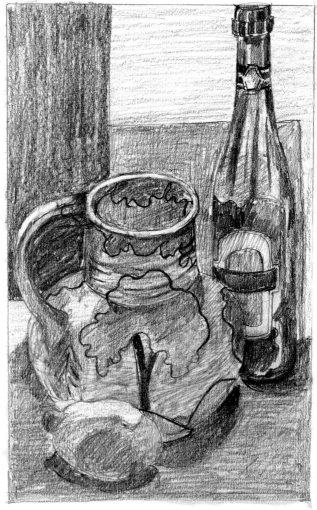

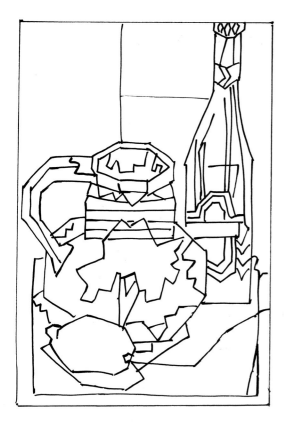

Stylizing the shapes

The next process is a simple one of stylization – you will be portraying the objects in their entirety but altering their shapes. Begin by tracing from your drawing, using a pencil. Draw in line only, describing shadows and tonal areas as linear shapes. Now change at least one aspect of the original lines. For example, you could straighten all curved lines (as I have done in my example) or curve straight ones. Try thickening some lines or 'wiggling' others.

Completing the painting

When your tracing is complete, transfer the image to your painting surface and begin adding colour. At this point, you could make more changes. You could change the original colours completely, or alter them only slightly, as in my example. Decide what kind of space you want on the picture plane and use tones accordingly (close tones will make the space appear shallow, while more contrasting tones will make it look deeper).

◄ To alter the shapes, I made a tracing of the original drawing using line only. I straightened all the curved lines, including the outlines of the shadows and the bases of the objects.

▼ **Jug Still Life**
watercolour and line on paper
21 x 14 cm (8 x 5½ in)
For the last stage, I transferred the tracing and painted the final piece. I kept mostly to the real colours but made them more muted, finishing with black outlines using a marker pen.

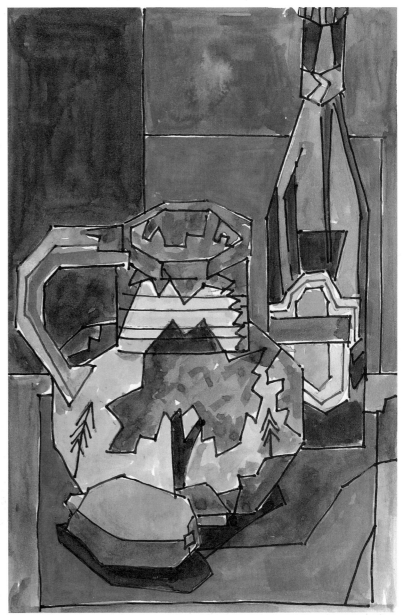

Perhaps you could outline the objects to emphasize them. The final result should be a somewhat stylized version of the original drawing, which, although not completely abstract, has certainly moved away from being wholly representational.

Using Photographs

Painting on location is not always easy, especially in a city where there are likely to be crowds, traffic and other distractions around you. It is especially challenging if you want to create abstract impressions of your visit, as it takes time and thought to decide what elements of a place you would like to extract and portray.

Taking photographs

This chapter deals with how you can use photographs as a resource to help you plan an abstract picture of a cityscape. But before you start taking photographs, the first thing to do on arrival at your destination is to have a good walk around. Really look at the streets and buildings, observing shapes and colours, and try to absorb the character and feel of the place, both visually and emotionally. Taking in the atmosphere of a city in this way will contribute to and enhance your finished paintings, enabling you to invest them with your own personal response to your visit. Then take down a few notes to remind yourself of your initial thoughts and feelings.

Once you have got a feel for your surroundings, arm yourself with a camera (digital or otherwise) and take as many photographs as possible. Look for unusual corners as well as the wider view and also take detailed shots, going in as close as your camera will allow. Once you have done this, you will be ready to go on to the next stage.

◀ This photograph shows the rooftops of the city of Prague. I love their colours and the way their shapes fit tightly together.

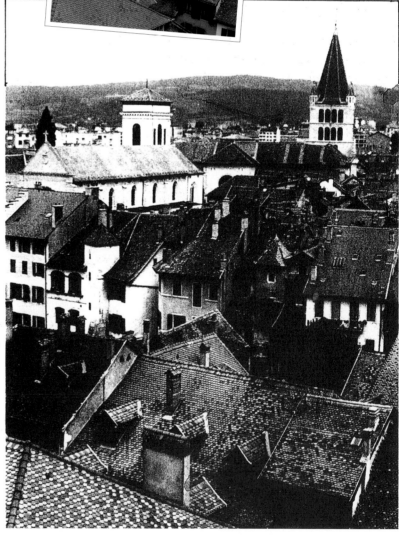

▶ The first stage was to make a black-and-white photocopy of the view in the photograph.

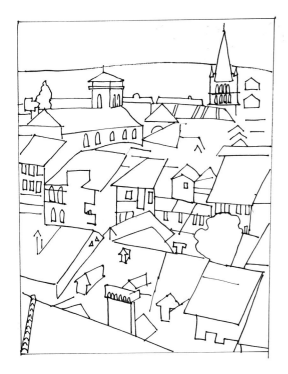

◀ From the photocopy I made a simple line drawing, picking out the basic shapes.

Tracing a picture is a good way to simplify it, as the tracing paper masks the details slightly, making it easier to select the important elements in the scene.

Preparing drawings

Once back in your studio armed with your photographs, begin to sift through until you find one you like. Take an A4 or A3 black-and-white photocopy of the image and use it as a reference to make a simple line drawing. You can draw freehand or trace the outlines of the image.

Now make a second, even more simplified version of the scene. To do this, take a piece of tracing paper and make a tracing that picks out the important elements. Try to be selective as you do this, extracting the main lines and shapes. Transfer this second image to your painting surface, ready to begin adding colour.

▶ I then made a tracing of the previous drawing, simplifying the image still further and at the same time emphasizing the many triangular shapes on the buildings.

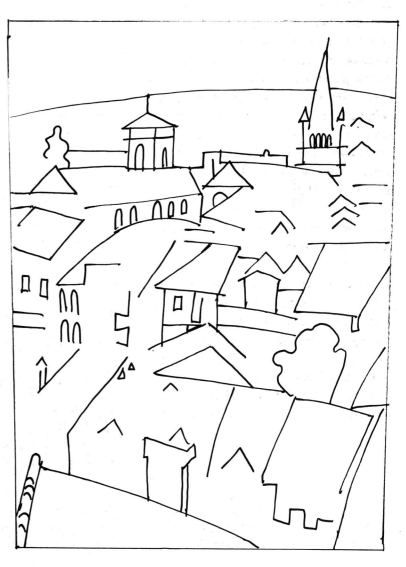

Painting the picture

Assemble a variety of different painting materials. By choosing mixed media, you are transferring the focus onto the actual paint marks rather than the realistic view in the photograph. At this point, you should still be thinking about what aspect of the city you want to concentrate on. Is it a 'tired' city or is it old yet still vibrant? Have you chosen a broad view of closely packed buildings or a close-up of one particular feature? Is it atmosphere you want to express, or cold, hard facts? Once you have chosen your particular focus, make sure you stick to it. I tried to focus on the geometric forms of the buildings rather than their weathered and ancient nature, heightening

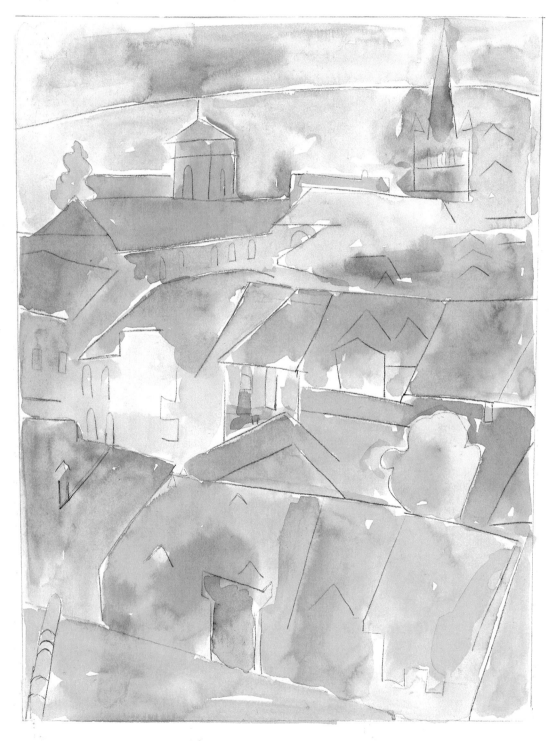

◄ I began the painting by blocking in the shapes with light washes of watercolour. I chose to heighten the real colours, placing them so that they would act as 'arrows' to guide the viewer's eye around the picture.

the colours to present a modern vision. Begin with light applications of paint so that you can build up the painting as you go along. I used initial washes of watercolour to block in the shapes of the buildings in my drawing.

As you begin to develop the painting, remember to design the picture, using colour, shape and line to guide the viewer's eye around it. Decide whether you want a flattened image or one with deeper spaces, and select a range of tones accordingly. Choose appropriate tools to make different marks – for example, I used a marker pen as a linear tool to describe some of the triangular roof shapes.

black lines emphasize important shapes

▶ **Roof Vista**
mixed media on paper
22 x 17 cm (8½ x 7 in)
Finally, I strengthened the colours, picked out architectural features and patterns in paint, and outlined some shapes in black.

simplified patterns represent the roof tiles

colours help to guide the eye around the painting – follow the sequence of yellow shapes from **a** through to **f**

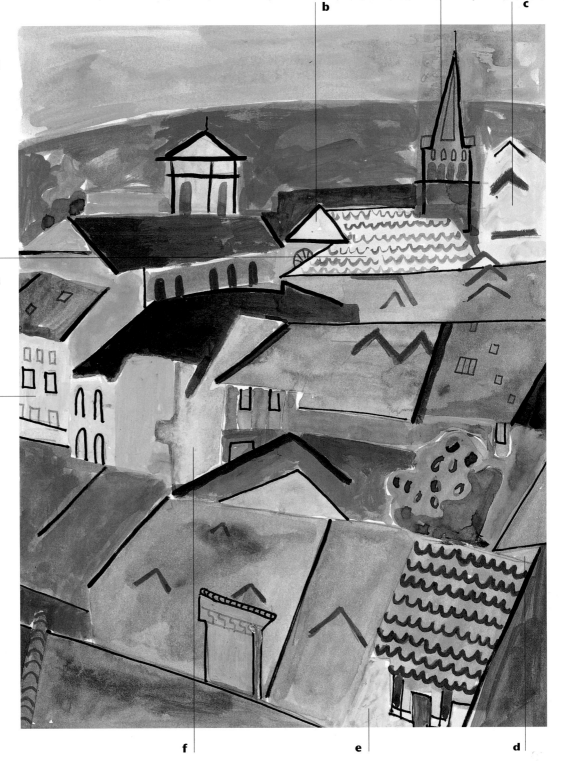

Cutting up a Drawing

Weather permitting, drawing or painting in the landscape is generally easier than in an urban setting. If you are well prepared, with something to sit on, your materials easily to hand and maybe a drink and a sandwich to keep up your strength, it can be a very satisfying experience.

Remember to take your camera with you – it is an essential addition to your tools when painting abstracts. Looking at your photographs will remind you about the area and its views, and may also prompt you to notice things you didn't spot at the time.

Begin with a tonal drawing

Whether you have decided to work from a photograph or a drawing, check the composition once you get back to the

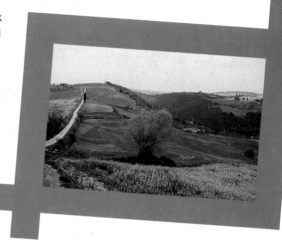

▶ I love the patchwork landscape of Tuscany. I used a photograph as a reference for my painting, cropping it with two 'L' shapes to obtain the strongest composition.

studio. Is it as strong as you would like it to be? If you have made a drawing, you might need to adjust it accordingly. If you are working from a photograph, crop it with 'L' shapes if necessary and then make a tonal drawing of the scene.

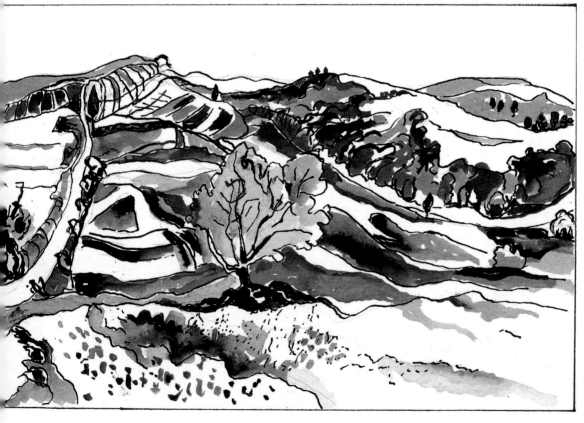

◀ To establish the main areas of tone, I made a pen, ink and wash drawing from my photograph.

► Having made a photocopy of the pen and ink drawing, I cut it into five uneven strips. I reassembled them at different heights, at the same time re-establishing the rectangle of the picture area.

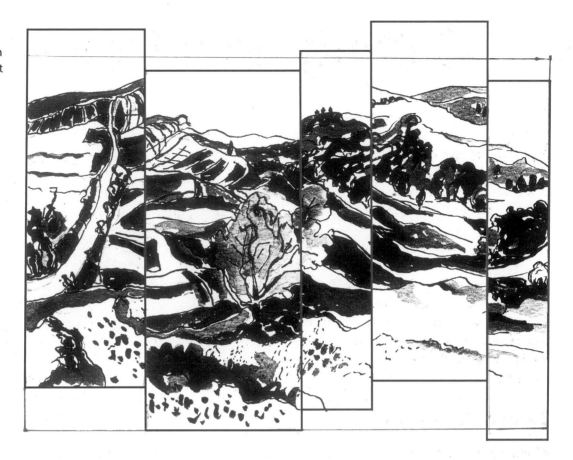

Cutting and pasting

As in previous chapters, the way to make an abstract version of your subject is by altering a more literal image. Make a photocopy of your drawing and cut it into strips. Now reassemble the strips – they can be in any order and at the same or different heights. Paste them down on to a piece of card or paper. This process will alter the image while still retaining the visual essence of the place.

Tracing and transferring

The next step is to use tracing paper to make a simplified line drawing of the staggered image. The tracing should have lots of lines and patterns from the landscape, incorporating incomplete edges as well as complete shapes. Transfer the traced image on to your painting paper.

◄ From the previous reconstruction, I made a line tracing ready to be transferred to my painting paper for the final piece.

► I selected some areas for treatment with a 'natural sand' texture gel or crumpled white tissue paper.

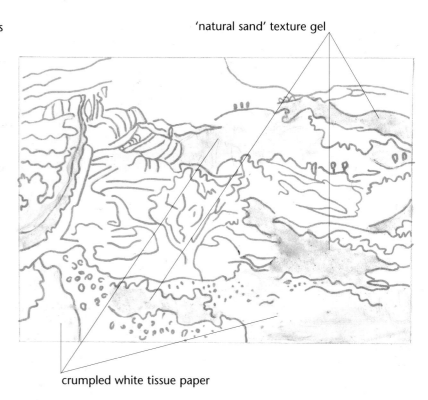

'natural sand' texture gel

crumpled white tissue paper

Adding textures

Landscape is an ideal subject for experimenting with elements of texture, using materials such as tissue paper and texture gels. Apply texture to the parts of the painting that you want to be most prominent. To create a rough surface, try a type of texture gel called 'natural sand'. For an interesting patchy effect, crumple small pieces of white tissue paper and stick them onto the surface with PVA glue. When you paint over the top of the textures, these areas will be emphasized.

a **b** **c** **d**

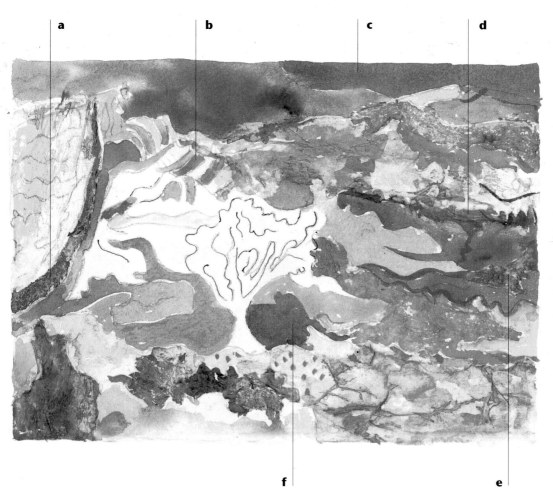

◄ I began painting, using watercolour and gouache. I kept to landscape colours but then added a rather unrealistic colour (purple) to pick out some shapes to help guide the viewer's eye around the painting from **a** to **f**.

f **e**

44

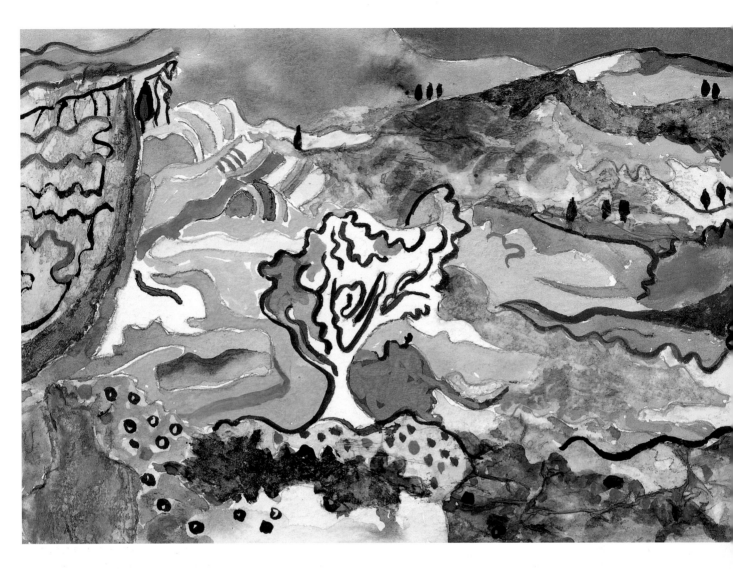

Painting the picture

Colours can be realistic but enhanced, so that the final piece still represents the landscape but in a more abstracted way, or they can be changed to suit the mood you want to capture. You can retain a sense of distance by using scale, making details such as trees smaller in the distance, for example. You can also suggest distance by using a wide range of tones. Alternatively, flatten the picture by using tones that are similar to each other. Try to pick out any visual characteristics of the area and emphasize them. In my example, I worked up the patterns typical of the Tuscan landscape.

▲ **Tuscan Hills**
mixed media on paper
15 x 22 cm (6 x 8½ in)
For the finished painting, I strengthened certain areas with colour and pattern. I also emphasized some shapes with darker lines and added a few details such as distant trees.

To get the exact shape you need when using tissue paper, trace the shape onto the tissue paper itself and wet the line with water. The shape will then tear away easily.

Extracting a Section

The abstract paintings in the last few chapters were largely based on the actual subject matter. Objects became stylised objects and landscapes became abstracted landscapes. Here, the starting-off point is a still life of rather ordinary objects but this time we are going to take a section from it and develop a painting from the resulting arrangement of lines. As no one object will be shown in its entirety, the image will appear to be abstract.

Drawing a still life

For your still life, choose objects that have varying shapes, forms, surfaces and textures. These can be ordinary everyday items from around your home – I chose a bulldog clip, a reel of cotton, a bottle of ink, a marble and a piece of patterned wrapping paper. Set them up in an interesting group, allowing some items to stand in front of others. Now, make a good tonal drawing of the still life, remembering to put in the shadows on the flat surface on which the objects are standing, as well as those on the objects themselves.

Preparing a tracing

Next, take up your trusty tracing paper ready to make a line drawing of the tonal picture. Remember to trace the shadows as shapes in their own right and don't forget to include the pattern on the coloured wrapping paper that covers the horizontal surface. The shapes of the pattern will provide some additional interesting lines that could be useful when selecting your composition. Now transfer the tracing on to a piece of cartridge paper,

▲ Using unrelated everyday objects, I set up a still life and made a detailed tonal drawing in pencil.

▼ I then traced the main outlines, making sure I included the shadow shapes and patterns such as those on the coloured wrapping paper.

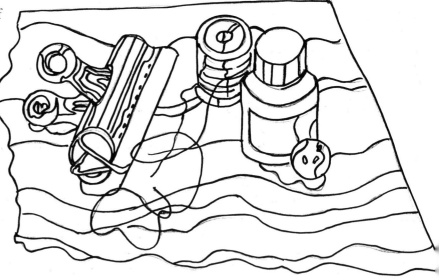

checking that you have included all the lines. In this way, you will have as much choice as possible when searching for a suitable image to paint.

Choosing a composition

It is a good idea to try out several compositions, as one drawing can be the source of many paintings. Use 'L' shapes to select interesting rectangular or square sections of the line drawing and mark round them with a coloured pen. I usually trace each of these compositions separately – although here I've just picked out three sections – so that I can see them without the clutter of the other lines around them.

Have a good look at each section and see what appeals. Do you like the one that consists mainly of straight and curved lines? Or do you prefer the one that isolates a particularly pleasing set of shapes? Hopefully one of your choices will speak to you and tell you it is longing to become an abstract composition!

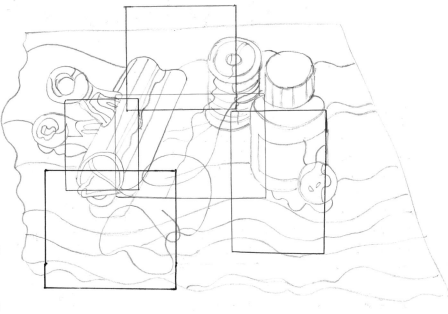

▲ Once the tracing was transferred to cartridge paper, I tried out composition ideas by using 'L' shapes to pick out rectangles and squares within the drawing.

▼ This option felt as though it was split into two different sections and the shape of the ink bottle was too obvious.

◀ I tried a squarer shape for this composition.

▶ I liked the large 'loop' shape here, so I decided on this composition for my painting. I drew two crossing lines to help with enlarging the image onto my painting surface.

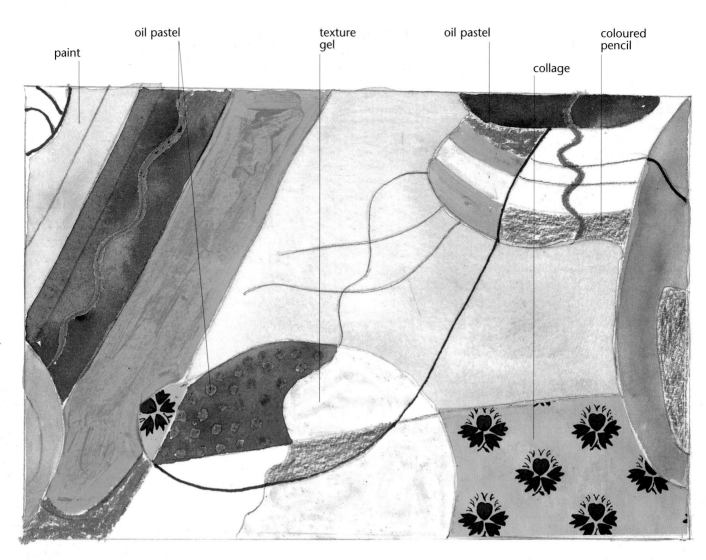

paint · oil pastel · texture gel · oil pastel · collage · coloured pencil

Transferring the image

Once you have chosen your composition, it needs to be enlarged onto paper or canvas. You can do this freehand – just try to redraw the lines as closely as possible to the original. Don't worry if you change them slightly in the process, as now it is the potential painting that matters and any changes are just another step towards the abstracted image.

Choosing a theme

It is a good idea to think of a theme for your composition. I decided to develop the example shown here using 'the garden' as my theme. A theme gives you something to 'cling on to' and suggests colours and textures that you could use in a symbolic way as part of the abstract process.

Now you are ready to begin painting. Be experimental with your materials, bringing in texture gels and collage if you wish. Don't be afraid to add extra shapes to the composition if they help tell the 'story' of your picture

▲ I painted some areas in watercolour and used texture gels to change the paper surface in others. I picked out patterns, shapes and lines with oil pastel and coloured pencil. Finally, I stuck on some flowered wallpaper as collage.

Don't add too much texture gel. If it stands out excessively, it can detract from the rest of the painting.

The end result

On completion, your painting should speak for itself. If the overall effect conveys something of what you set out to say, then you will have created a successful piece of work. In my abstract example, the finished painting symbolizes the way in which a garden can be regarded as an organized version of the countryside.

▶ This detail shows how the heavier oil pastel marks stand forward from the watercolour areas, looking as dominant as the collaged green leaf shapes.

▼ **Everything in the Garden**
mixed media on paper
16 x 24 cm (6 x 9½ in)
To complete the work, I drew some flower motifs (**a**), adding green paper leaves (**b**) in collage, a gate in red line (**c**) and branch shapes (**d**).

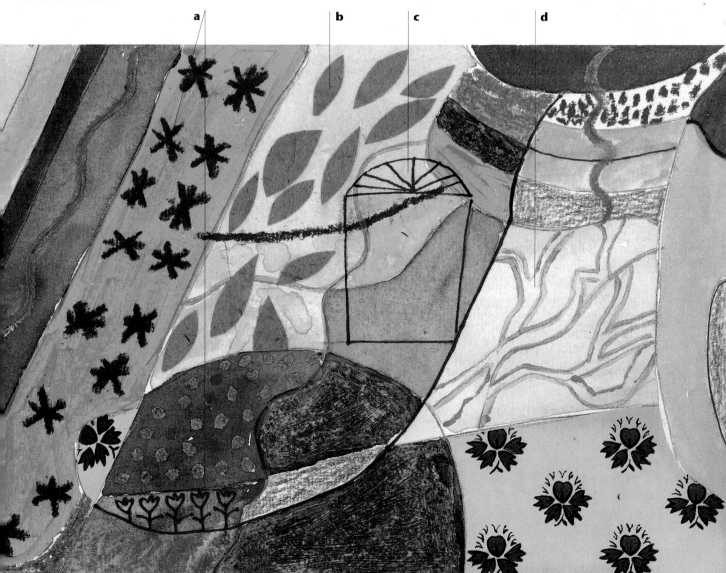

The Emotional Response

Most artists wish to incorporate their own personal response to a subject into their work and try to invest their paintings with emotions that will 'speak' to the viewer. Even more than figurative painters, artists seeking an abstract approach to painting need to look beyond the 'real' and paint about the meaning or essence of their chosen subject. Because of the nature of their work, they have to do this by way of symbols and marks.

Using visual symbols

How can you, as an abstract artist, capture a certain mood? The answer is not just about how you place colour, lines and brush strokes, but also about what you want these elements to say. You must find symbols to portray this.

Artists have always used symbols to express their 'stories' – prehistoric cave paintings are a good example of this. You

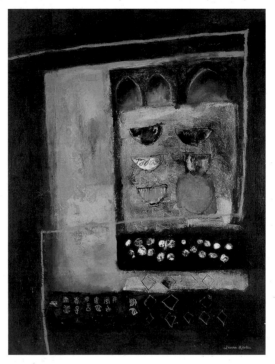

◄ **Blue Mood**
mixed media on canvas
45 x 60 cm (18 x 24 in)
Although the blue used here is a rich hue, the mood is cool. The painting represents objects in an enclosed space surrounded by gold. I used gold to make the objects seem precious and special, like objects in a museum or temple.

can use colour, for instance, as a symbol to express mood or atmosphere, so that an abstract painting based on, say, a journey to a hot place could be predominantly in yellows and oranges. Equally, to indicate clearly that your painting represents a certain country, such as India, you could use shapes found in the local buildings or patterns seen on ethnic textiles (as I have done in my paintings).

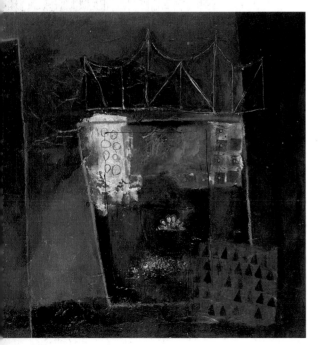

◄ **Thai Red**
mixed media on canvas
60 x 60 cm (24 x 24 in)
As the title suggests, this painting is a response to my visit to Thailand. I used the red colour that is so prevalent in that part of the world to suggest both the culture and the heat, and I incorporated gold areas into the composition for the same reasons. The patterns symbolize the many decorative surfaces found in all areas of Thai life.

Capturing mood and emotion

Sometimes abstract artists achieve mood and emotion by working consciously with previous thought, making deliberate decisions about colours and shapes. At other times, they work more instinctively, picking up colours just because they like them and making marks without consciously thinking. They just work freely, so that shapes can emerge, and they make decisions later when it becomes clear how their materials are interacting.

Whether you are working consciously or instinctively, the possibilities for capturing atmosphere and emotion are endless. The most important thing is to be experimental with your materials and mark making. If you are going to take the instinctive route, begin in an almost accidental way, starting with marks, washes, shapes and lines. Watch how these marks work together – in this way, you are in effect letting the painting tell you what it is about. But if you prefer, work to a theme, perhaps a memory of a place or event, from the outset.

Try this useful mark-making exercise. Take a large sheet of paper and have a wide variety of materials to hand. Make as many different marks on the paper as you can and then find words to describe the moods they suggest to you. Jot these down next to the marks to create an invaluable vocabulary of visual symbols for future use.

Reading your painting

Finally, be connected with your painting so that you can 'read' it and respond to each mark you make. Stop work frequently and look at the painting from a distance. Try to see what the colours, marks and textures are suggesting to you. Reading a painting is similar to reading words – you are just looking at visual marks instead of letters. It takes practice to let go of the idea that painting has to be realistic but once you do, you can achieve free and exciting work!

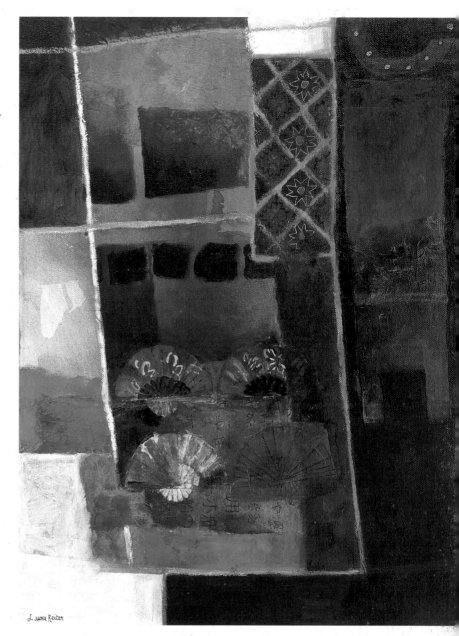

▲ **Floating Market**
mixed media on canvas
60 x 45 cm (24 x 18 in)
The floating market in Thailand is a busy, vibrant place full of merchandise, which is symbolized by the fan shapes. Shaded from the sun, this 'market jetty' has many dark corners offering hidden surprises. I tried to evoke these places using rich, dark tones of purple and brown together with contrasting light tones nearby. The shapes were abstracted from the many photos I took at the time.

Pink Watermelon

This demonstration shows how you can make an abstracted painting from a realistic beginning by using stylization. I took natural objects as my starting point, with the idea of creating a more geometric composition. I chose a slice of watermelon (because I love its shape and startling colours), a bulb of garlic, a few mushrooms and some leaves in a small pot.

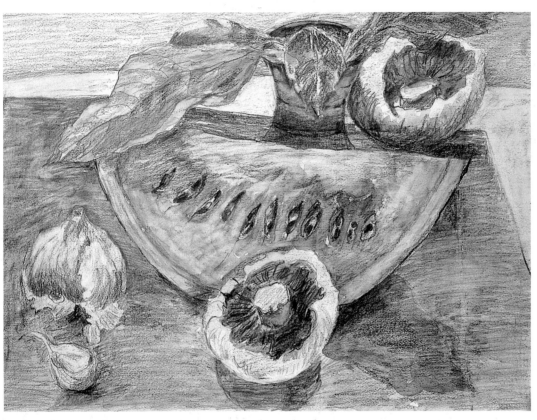

Colours

Light Grey (oil pastel)

Brilliant Blue (watercolour)

Cadmium Orange (watercolour)

Rose (watercolour)

Winsor Red (watercolour)

Light Green Permanent (acrylics)

Bright Aqua Green (acrylics)

French Ultramarine (acrylics)

Burgundy (acrylics)

Buff Titanium (acrylics)

Gold (acrylics)

First Stage

First I set up my still life, allowing the objects to overlap to make interesting shapes. I put them on a piece of coloured paper, so that I could use it to divide the composition up in a dynamic way. Working with soft pencils (4B and 6B), I made a tonal drawing on heavy cartridge paper, putting in as much detail as I could so that I had plenty of material to work from at the

▲ First stage

next stage. I kept in mind that shadows cast on the paper also provided useful shapes.

Second Stage

Having pinned my drawing up in front of me so that I could see it easily, I made a line drawing from it, using light pencil first and then strengthening this with Light Grey oil

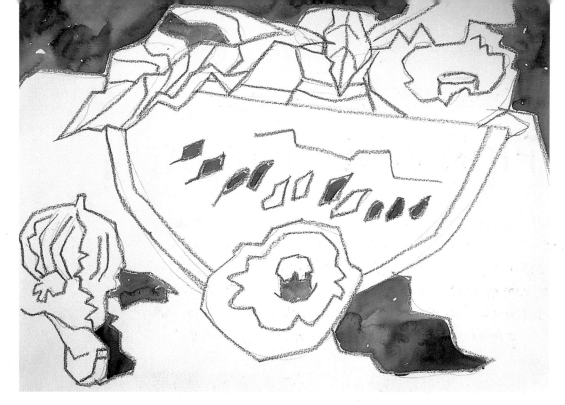

pastel. However, instead of reproducing the objects realistically, I straightened all their curved edges, producing a geometric version of the composition. I then used Brilliant Blue and Cadmium Orange watercolour to fill in a few of the spaces – first the background and then one or two

shapes and shadows. The oil pastel resisted the paint, making it easy to do this.

Third Stage

Although I could have changed colours completely, I decided to keep to the actual colours but to heighten them so that they

▶ Third stage

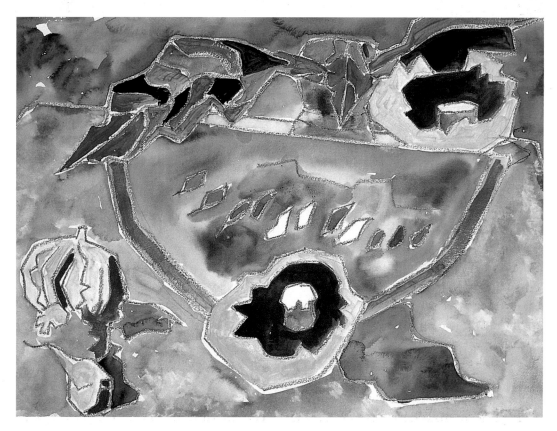

were unrealistically bright. I again used watercolour: Rose for the body of the melon and Winsor Red for the wrapping paper. I also strengthened the blue background. Changing to acrylics, I continued to paint the rest of the shapes, using Light Green Permanent for the skin of the melon, Bright Aqua Green for the green part of the leaves and French Ultramarine for the darker areas. I chose Burgundy and Buff Titanium for the mushrooms and garlic. As the colours became darker, the light grey pastel showed up more.

Finished Stage

The finishing touches were added at this stage. I chose Gold acrylic paint to highlight small parts of the pips on the melon, as I love their shape and wanted them to seem important in the painting. I also added Gold acrylic details to the mushrooms. Finally, I had a good look at the painting and realized that the area of coloured paper needed an element of pattern. To provide this, I used my Light Grey oil pastel to create parallel vertical lines, which helped to flatten the overall image and link this area more appropriately to the flat, geometric shapes of the other objects.

▶ **Pink Watermelon**
mixed media on paper
29 x 40 cm (11½ x 16 in)

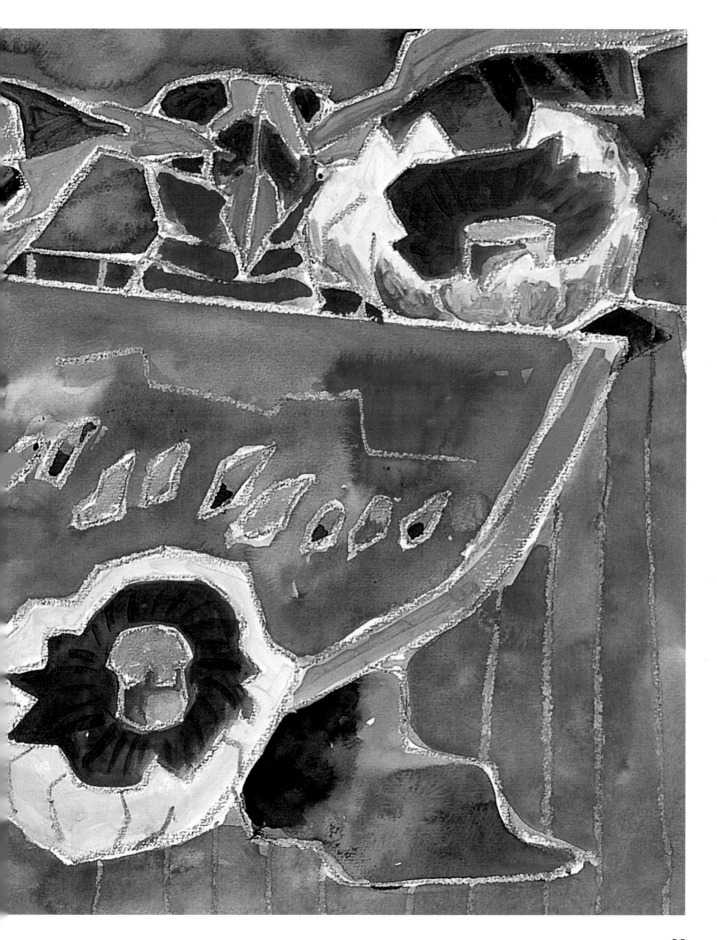

Wood for the Fire

There are many ways of beginning an abstract painting. This demonstration shows how taking a section from a realistic drawing can lead to an exciting composition. It is a way of finding fantastic shapes and can provide an endless source of inspiring ideas for paintings.

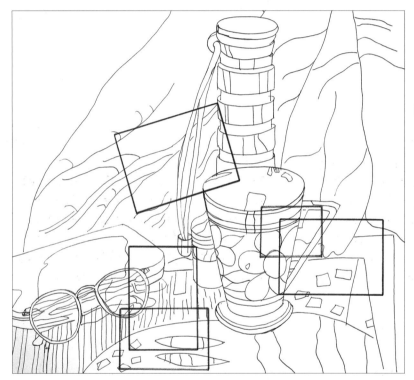

▶ First stage

Colours

 Indian Yellow (watercolour)

 Cadmium Orange (watercolour)

 Burnt Orange (watercolour)

 Cadmium Yellow (watercolour)

 Cadmium Red (watercolour)

 Orange (oil pastel)

 Flame Orange (acrylic ink)

 Mauve (watercolour)

First Stage

For my still life, I chose objects that had different qualities in terms of shape and were not related to each other in any way. These were a pair of spectacles and a spectacles case, a torch with a cord attached and a decorative mug. I arranged the objects on a piece of patterned wrapping paper with some fabric draped behind them. I then made a line drawing with a drawing pen, making sure that I included the shadow shapes. Using a pair of card 'L' shapes, I proceeded to select five sections of the drawing that could potentially be used for my composition. I marked the outlines with coloured felt-tipped pens, so that they could be easily identified against the drawing as a whole.

Second Stage

I chose the composition at the top left of the drawing, which included part of the torch and its cord, some fabric shapes and a section of the ellipse of the mug. I felt that the shapes in this composition provided me with a good variety of lines, spaces and

◄ Second stage

shapes that had a lively diagonal sweep from left to right. Using a 2B pencil, I transcribed these shapes freehand onto a piece of Bockingford 300 gsm (140 lb) watercolour paper. I then painted a few of the shapes with washes of watercolour in Indian Yellow and Cadmium Orange.

Third Stage

I was beginning to get an idea about how I wanted my painting to progress. The two shapes in the centre of the page reminded me of tree trunks and the diagonal orange shape seemed quite flame-like. By treating the shapes as symbols in this way, I gave

► Third stage

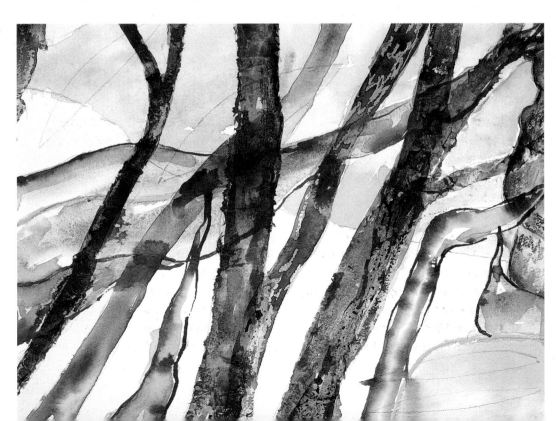

myself a theme to work to and created a subject for my painting. I added in some more 'tree trunks' and 'flames', sticking crumpled white tissue paper onto some of the trunks and drawing with a white wax candle on others. I then enhanced the colours, using Burnt Orange, Cadmium Yellow and Cadmium Red watercolours.

Finished Stage

Using an Orange oil pastel, I drew into the 'flames' and then painted them with some translucent acrylic ink in Flame Orange. I felt that the painting lacked a little in atmosphere and could be improved by darkening the background. Mixing Mauve and Cadmium Yellow watercolours to create a neutral mauve-brown, I painted a transparent wash in the background, leaving only four yellow shapes to allow some light to shine through. I then darkened the top half of the background with another layer of the same colour.

▶ **Wood for the Fire**
mixed media on paper
28 x 38 cm (11 x 15 in)

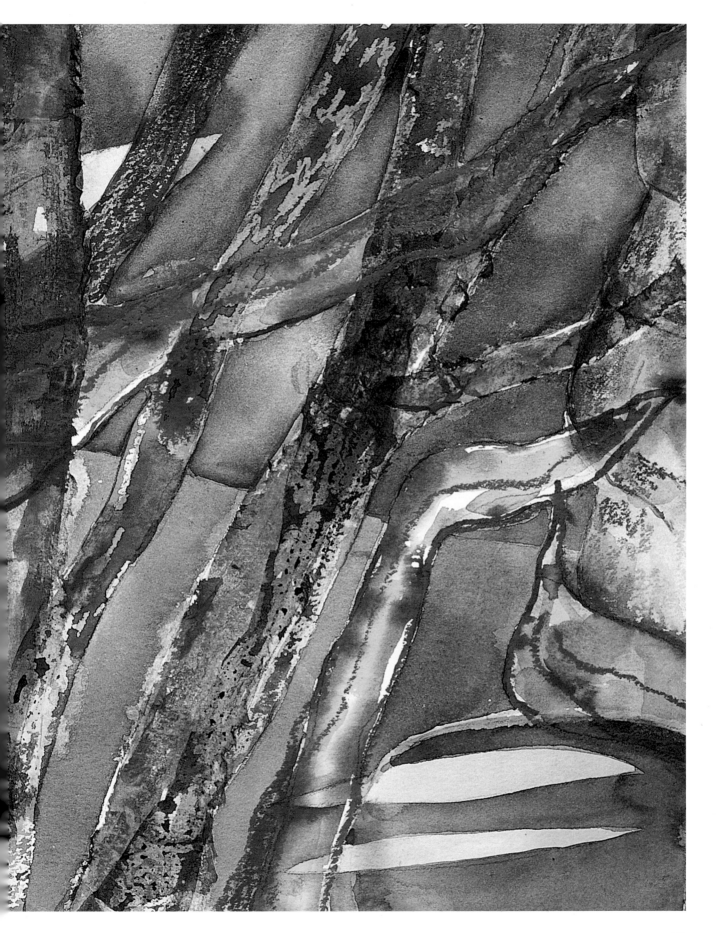

Moonshine

Starting a painting with random marks is the freest way to begin and is a playful, experimental way to work. By making marks and laying down washes, you can encourage ideas to emerge from your subconscious, resulting in exciting and often surprising images. The main thing is that this process should be an adventure!

Colours

Winsor Blue (watercolour)

Cobalt Turquoise (watercolour)

Brilliant Blue (watercolour)

Rose Madder (oil pastel)

Cadmium Orange (watercolour)

French Ultramarine (watercolour)

First Stage

▲ First stage

The only theme I chose at this stage was to use a range of blues for my painting. Working on Bockingford 300 gsm (140 lb) watercolour paper, I laid down three layers of watercolour washes in Winsor Blue, Cobalt Turquoise and Brilliant Blue. While the first layer was still very wet, I sprinkled some rock salt onto it in order to create a dramatic mottled texture. By doing this, I was able to establish a little more than just colour for the background to the painting.

Second Stage

Using a Rose Madder oil pastel, I drew curving lines to divide my paper into a 'cruciform' composition. I felt I needed some more information in the composition,

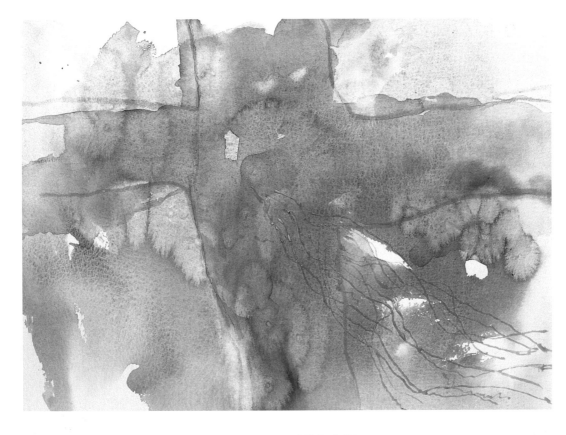

so, in order to preserve some light marks, I drew wiggly lines from the centre to the lower right-hand corner with masking fluid. Next, I used a complementary Cadmium Orange watercolour to paint a light orange shape to represent some warm light filtering through the cool blues.

Third Stage
I looked my painting constantly to get a feeling for what it was about. My thoughts at this point were about the organic nature of the marks I had made. However, I didn't feel the need to develop them further, because the painting should be able to exist

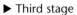 ▶ Third stage

in its own right as a composition about colour, atmosphere and texture. The next stage was to add some collage – a torn strip of dark blue handmade paper with embossed silver marks – to create a band curving upwards from the base of the painting. I then reinforced the blue 'cross' shape with a wash of French Ultramarine and darkened some spaces between the masked lines with the same colour. Finally, I used a bottle top to print an orange circle just below the initial light orange area, which could represent a full moon shape.

Finished Stage

By this stage, the painting was almost complete. I felt that I wanted to emphasize the circular moon printed in the previous stage, so I stuck some crystal beads around its edge. Then, to unite the left- and right-hand sides of the painting, I drew some broken lines with a gold metallic brush pen. These echoed the embossed marks on the collaged paper, linking it to the edge. Finally, I removed the masking fluid by rubbing gently with my finger to reveal the light lines underneath.

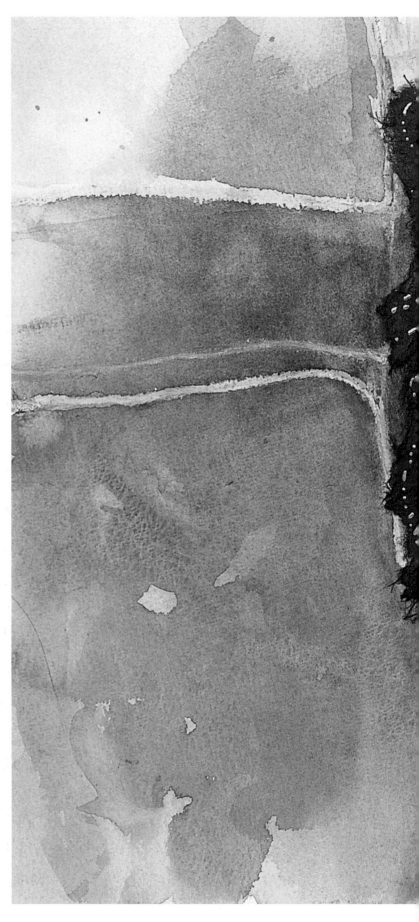

▶ **Moonshine**
mixed media on paper
28 x 38 cm (11 x 15 in)

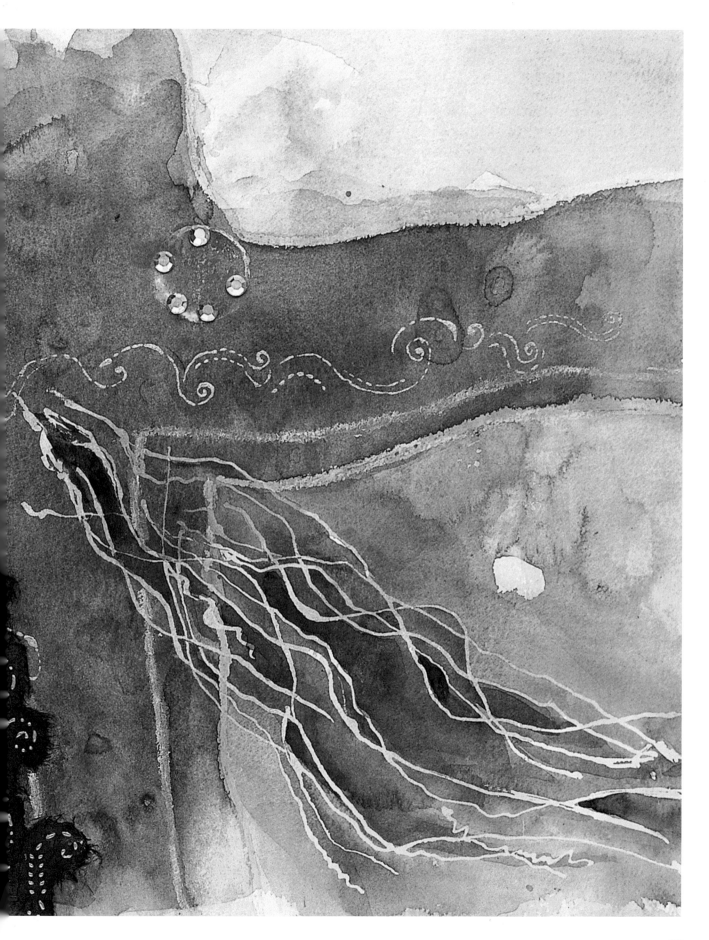

Collins

THE NEXT STEP...

If you have enjoyed this book, why not have a look at other art instruction titles from Collins?

Other titles in the *Learn to Paint* series include:

And if you want to take your painting further, try these titles:

To order any of these titles, please telephone **0870 787 1732**
For further information about Collins books, visit our website:
www.collins.co.uk

Some other addresses and websites you might find useful are:

ART MAGAZINES
The Artist, Caxton House, 63/65 High Street, Tenterden, Kent TN30 6BD; tel: 01580 763673
www.theartistmagazine.co.uk
Artists & Illustrators, The Fitzpatrick Building, 188-194 York Way, London N7 9QR; tel: 020 7700 8500
Leisure Painter, Caxton House, 63/65 High Street, Tenterden, Kent TN30 6BD; tel: 01580 763315
www.leisurepainter.co.uk

ART MATERIALS
Daler-Rowney Ltd, Bracknell, Berkshire RG12 8ST; tel: 01344 424621
www.daler-rowney.com
Winsor & Newton, Whitefriars Avenue, Wealdstone, Harrow, Middlesex HA3 5RH; tel: 020 8427 4343
www.winsornewton.com

ART SOCIETIES
Society for All Artists (SAA), P. O. Box 50, Newark, Nottinghamshire NG23 5GY; tel: 01949 844050
www.saa.co.uk

BOOKCLUBS
Artists' Choice, P. O. Box 3, Huntingdon, Cambridgeshire PE28 0QX; tel: 01832 710201
www.artists-choice.co.uk

INTERNET RESOURCES
Artcourses: an easy way to find part-time classes, workshops and painting holidays
www.artcourses.co.uk
Laura Reiter: the author's website, with details of her courses, exhibitions and a gallery of her paintings
www.laurareiter.com
Painters Online: interactive art club run by The Artist's Publishing Company
www.painters-online.com

VIDEOS
APV Films, 6 Alexandra Square, Chipping Norton, Oxfordshire OX7 5HL; tel: 01608 641798
www.apvfilms.com
Teaching Art, P. O. Box 50, Newark, Nottinghamshire NG23 5GY; tel: 01949 844050
www.teachingart.com